READ THIS IF YOU WANT TO TAKE GREAT PHOTOGRAPHS OF PEOPLE.

Published in 2015 by
Laurence King Publishing Ltd
361–373 City Road
London EC1V 1LR
e-mail: enquiries@laurenceking.com
www.laurenceking.com

Reprinted 2015 (twice), 2016

This book was designed and produced by
Laurence King Publishing Ltd, London.

A catalogue record for this book
is available from the British Library.
ISBN: 978-1-78067-624-1

Picture research: Peter Kent
Illustrations: Carolyn Hewitson

Printed in China

READ THIS IF YOU WANT TO TAKE GREAT PHOTOGRAPHS OF PEOPLE.

HENRY CARROLL

LET'S START WITH YOU6

CONTEXT26

COMPOSITION8

THE GAZE42

Let's start with you

Close the book. Take a long look in the mirror and ask yourself, *'who am I and why do I want to take photographs of people?'*

Answer that and you're well on your way to becoming a great photographer. That's because the best photographs of people don't just tell us about the person in the picture. They also tell us about the person behind the camera – you.

Here we have 50 photographers, all masters of their craft, with very different approaches to photographing people. Get a feel for their pictures and you'll unlock a world of ideas and techniques that will inspire you to discover your own unique way of photographing people. But let's get one thing straight from the start.

Don't take pictures *of* people. Take pictures *about* people.

To do this you need to embrace your creativity. OK, so a little technical knowledge is important too and I'm going to assume you know some fundamentals, like the difference between shutter speed and aperture, leading lines and the rule of thirds.

If that last sentence made no sense at all, then I recommend you read *Read This If You Want To Take Great Photographs*. This covers the basic techniques and much more. But try not to get too distracted by the techie stuff, because picking up techniques is easy. Figuring out how and why you want to photograph people is much, much harder.

The good news? This book is going to help you do just that. The tricky part is that you're going to need to think hard about yourself and how you relate to others. But before I put you off with all this touchy-feely talk, let's distil everything down to the one golden rule of photographing people.

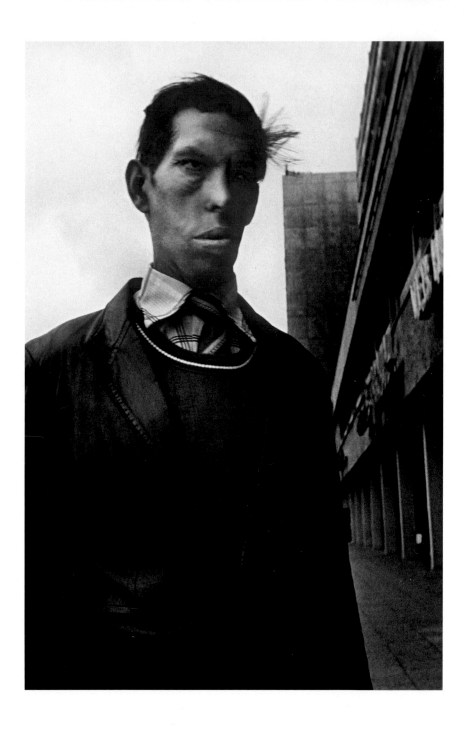

Trust your 'visual instinct'

Composition isn't about making photographs that *look* right. It's about making photographs that *feel* right. There are 'rules' – you probably know most of them – but they're not actually 'rules'. They're more like guidelines which you're free to follow or completely ignore.

In fact, when your subject is as diverse as people, there's only one rule you need to follow – trust your visual instinct. Who are you photographing? What's their mood? What's your mood? Where is the shoot taking place and what's going on around you? These are the things to feed off and this first chapter will tell you how.

Listen to what your gut is telling you about your subject and the situation.

Sometimes your visual instinct will lead you to a composition that does follow clear-cut rules. Other times it will lead you to something where the rules simply do not apply. As we're going to see, both outcomes can be equally powerful, as long as you let your gut feeling lead you there.

19 September 1983,
East Berlin
Keizo Kitajima

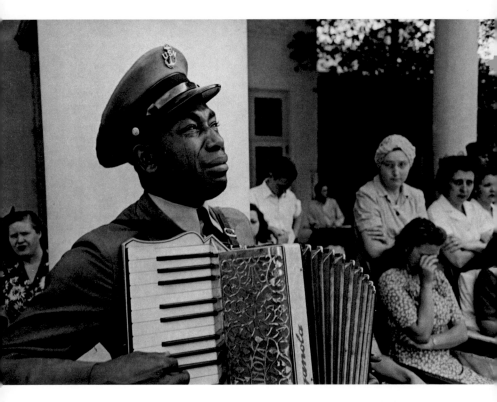

Navy bandsman
Graham Jackson

Ed Clark

1945

Keeping it
by the book

If there's ever a portrait which uses the rules so sublimely, it's this one by Ed Clark.

The man in the picture is Chief Petty Officer Graham Jackson. His tears are for the funeral train which rolls past carrying his dead president, Franklin D. Roosevelt. On his accordion he plays 'Goin' Home', but you're already hearing that solemn tune with your eyes, aren't you?

Rule of thirds. Lead room.
Framing. It's all here.

Photographs like this don't respond well to visual autopsies, so I'll keep this brief. The subject is positioned a third in from the left-hand edge of the photograph and his eyes lie a third in from the top: rule of thirds. There's plenty of room on the right, which allows his line of sight to move across the frame: lead room. He's positioned in front of a white pillar which creates a clean space in an otherwise busy composition: framing.

By keeping things 'by the book' you, the photographer, fade into the background. But that's no bad thing because sometimes it's best to keep quiet and let your subject do all the talking.

It's the simple, timeless nature of these compositional commandments that keeps CPO Jackson's sad song playing decades later, long after he wiped away his tears.

For other examples:
Margaret Bourke-White p.32
Hippolyte Bayard p.69
Robert Doisneau p.82

Link the layers

For other examples:
Donovan Wylie p.26
Henri Cartier-Bresson p.76
Duane Michals p.106

Tapping his tobacco tin on the table, a cattle farmer sits powerless as his fields burn in an uncontrollable bush fire. The task of the photographer, Sam Abell, is to capture his subject's preoccupation. How does he do it?

It's all in the layers. Can you see how each element is perfectly positioned against the next? The man occupies his space at the table. His granddaughter occupies her space on the bed. The bullhorns occupy their space on the wall above them. Three key compositional elements, none of which overlap or interfere with the other.

Keep one eye on your subject and the other on the background.

On a basic level, we all know the classic 'tree growing out of head' photo faux pas. This occurs when you don't see the relationship between the foreground and background layers. Your subject is almost always set against something. Make sure you adjust your position, or theirs, to ensure the layers are working together.

Layering your composition takes the viewer on a journey, like telling a story. Here we encounter the burdens of adulthood, then the innocence of childhood and then a stoic reminder of the whole family's livelihood. This layering powerfully communicates that this man's responsibilities do not end with his farm. They end with his family.

Rancher John Fraser and his granddaughter Amanda
Sam Abell
1996

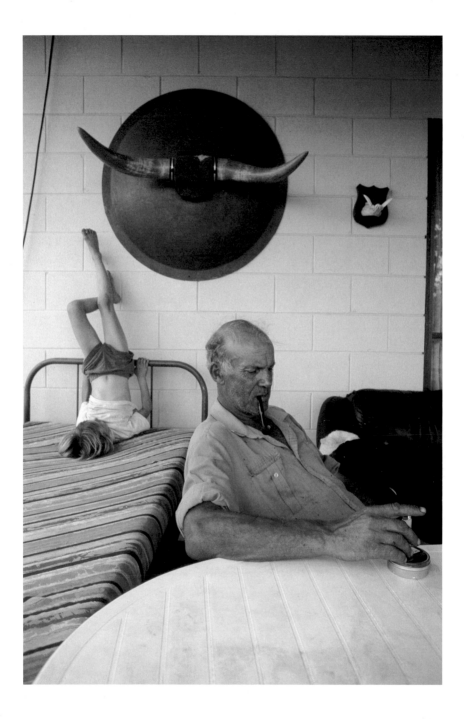

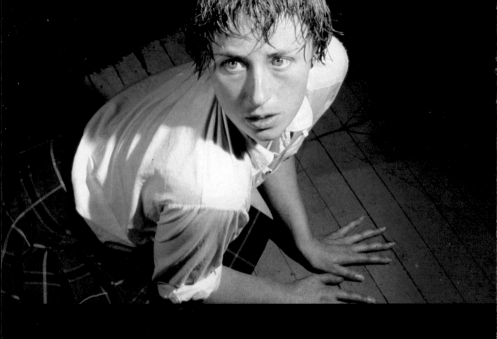

What's your angle?

Cindy Sherman is best known for photographing herself acting out a variety of clichéd depictions of women in cinema, from femme fatale to seductress, to girl on the run, to victim of domestic abuse.

Sherman uses extreme camera angles to manipulate our perception of her alter egos. Here we look down on her, which, combined with the fact that she's hunched over on the floor and wearing a schoolgirl's uniform, makes her seem totally vulnerable to an unseen attacker. It's a disturbing, but slightly humorous, nod to the absurdity of female identity on screen.

Camera angle instantly affects the viewer's perception of your subject.

Turn back to page 8 and Keizo Kitajima shows us the opposite approach. When photographing people on the street Kitajima gets in close and 'shoots from the hip', looking up at his subjects. This point of view causes the people in his pictures to tower up within the frame. Anonymous strangers take on a monolithic, all-powerful presence. Suddenly we, the viewers, are the vulnerable ones.

But it's not always about crazy angles. Often your visual instincts will tell you to go for something more neutral, to put the viewer on a par with your subject. As a rule of thumb, for headshots be in line with the tip of your subject's nose. For three-quarter length portraits line up with their chest. And for full-length portraits line up with their waist.

For examples of neutral camera angles:
Gillian Wearing p.87
Jeff Wall p.88
Thomas Ruff p.114

Head shots

For other examples:
Philip Haynes p.34
Bill Henson p.118
Robert Bergman p.121

You're looking at the face of the forgotten, a landless girl who has become a potent symbol of all those left behind by the rush of globalization. And she, with eyes that just don't stop looking, gazes out at us, the faces of the fortunate few.

Sebastião Salgado's photograph is about as classic as portrait compositions get. The tight framing draws us in, without distraction, to the girl's eyes and all that they say. She fills the frame, but isn't cramped. There's space above her head, but not too much. The neutral viewpoint eliminates any judgement caused by a high or low angle. It all looks so simple, but if any of these compositional subtleties are slightly off, your portrait will turn to pudding.

Nothing impacts your composition more than your choice of lens.

To create a composition like this you need to use a lens with a standard or long(ish) focal length (see p.25), commonly referred to as a 'portrait lens'. This causes your subject to stand out against a soft background and the tight frame cuts away any distracting environmental details, making it all about the eyes.

Salgado is a photographer who operates on instinct, and his emotional connection with those he photographs informs his compositional choices. You can turn the page, but this girl's inquiring eyes will be looking at you forever.

*Young, landless girl,
Parana, Brazil*
Sebastião Salgado
1996

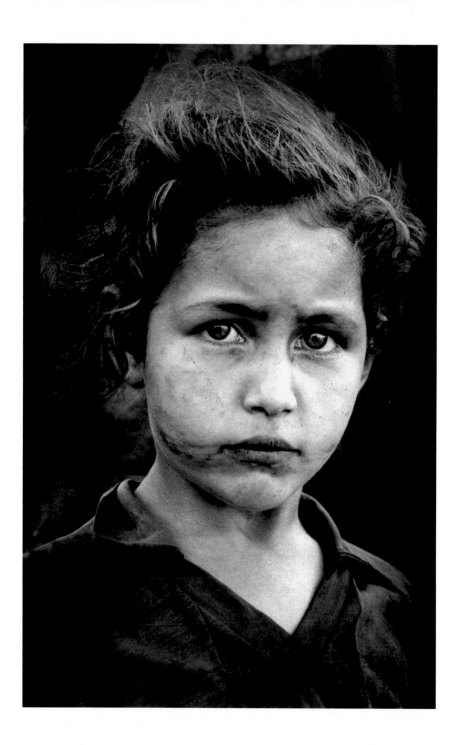

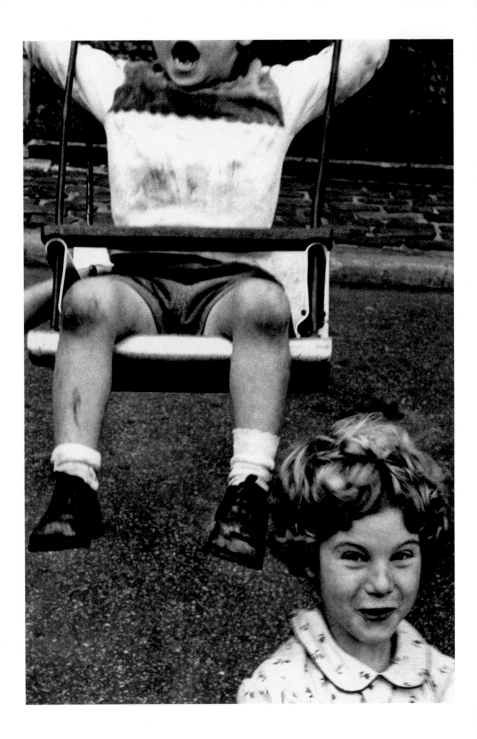

Create your own rulebook

A 'good' composition is not always something that's ordered and comfortable on the eye. Here William Klein photographs kids at play and, like so many of his pictures, this one adheres to no clear-cut compositional rules.

The elements feel like they have been collaged together at random. All we see of the boy's face is his gaping mouth, while his eyes and nose have been cut off by the top of the frame. As for the girl, she pops up in the bottom corner like a hallucination. Blink and she might disappear.

Some subjects demand a composition which is altogether different.

When photographing people there's a natural tendency to position subjects comfortably within the frame and treat the edges like buffer zones. By placing your subject at the peripheries you upset the balance and draw the viewer's eye away from the centre. It's a technique that goes against every rule, and that's exactly the point.

By throwing us a compositional curveball, Klein creates a disorientating image which captures the hyperactive energy of the children. With no apparent order, our eyes are taken on a spiralling joyride fuelled by fizzy pop.

For other examples:
Zed Nelson p.21
Arnold Newman p.22
Donovan Wylie p.26

Boy + Girl + Swing, New York
William Klein
1955

It's all in the details

For other examples:
Will Steacy p.37
Otto Steinert p.85
John Coplans p.92

The man in Zed Nelson's picture stands facing the camera, exactly as one does when posing for a portrait. But rather than compose the shot around the subject's head, shoulders and upper body, Nelson focuses on his waist.

What do we make of a man who stands in the desert wearing a knife, a pistol and a belt buckle emblazoned with the Star-Spangled Banner? These details say so much about the subject. And the fact that we can't see his face makes him all the more intriguing.

Don't let your preconceptions about portraiture interfere with what your instincts are telling you.

Your composition doesn't need to prioritize your subject's face. Sometimes that's just not important. Study your subject – look at their shoes, their jewellery, the way they've combed their hair. These are the details which often let slip who they are.

Break free from the limitations of compositional conventions and your visual instinct will speak to you that little bit louder.

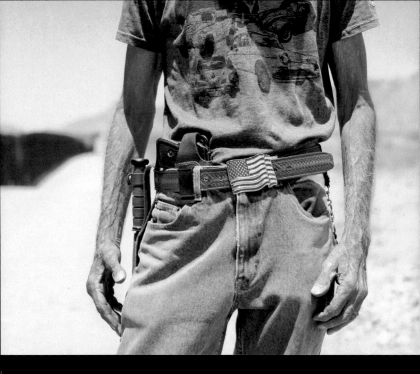

George Sprankle
from the series 'Right Wing
Along the Rio Grande'

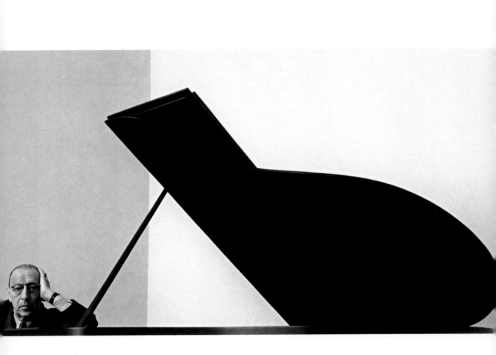

Russian composer
Igor Stravinsky

Arnold Newman

1946

A meeting of minds

Rather than position his subject, the composer Igor Stravinsky, comfortably within his picture, Arnold Newman places him to the very edge of the frame and draws our attention to his piano. Dwarfed by the shape of a giant musical note, Newman's incisive portrait playfully reminds us that the music maketh man.

Use your composition to draw out your subject's individuality.

Everyone you photograph is different. By figuring out their unique qualities – perhaps something about their personality, career or physicality – you can start to build compositions which capture this individuality.

Of course, it helps to pick subjects that you have an affinity with. It was the meeting of minds between photographer and subject that sparked this inspired composition. Newman paid little heed to compositional rules and Stravinsky confessed, 'I haven't understood a bar of music in my life, but I have felt it'.

For other examples:
Donovan Wylie p.26

Focal length and composition

The focal length of your lens has more say in your final composition than anything else. Focal lengths, whether short, standard or long, each have very distinctive traits so you need to make sure that you use the right focal length to communicate what your visual instinct is telling you.

Short/wide-angle

Use a short focal length if you want your composition to include the surrounding environment (see p.13). Pay extra attention to how your subject is positioned so they don't get lost against all the detail. Distance will appear elongated so you generally need to be closer to your subject. Depth of field will be much deeper, meaning more of your image will be in focus. With close-ups, your subject's features will look distorted.

Standard

A standard focal length gives a slightly tighter composition. Depending on your distance, the surrounding environment will still play a part, but your subject will tend to fill more of the frame. Distance will appear similar to what you would see with the naked eye (see p.10). Depth of field will be shallower, meaning the background will be out of focus. This brings your subject forward. With close-ups, there will be slight distortion of features, but nothing too obvious.

ON YOUR CAMERA:
Four thirds: <18mm
APS-C: <24mm
Full Frame: <35mm
6x6 Medium Format: <50mm
4x5 Large Format: <120mm

ON YOUR CAMERA:
Four thirds: 25mm
APS-C: 35mm
Full Frame: 50mm
6x6 Medium Format: 80mm
4x5 Large Format: 150mm

Long/Telephoto

Lenses with slightly long focal lengths are described as portrait lenses. Almost all environmental detail will be excluded due to the tight frame and very shallow depth of field. This will really bring your subject forward and focus all attention on them (see p.17). Watch out for subtle things like jewellery, logos and bogies, because these will become much more noticeable. Features will not be obviously distorted.

Lens distortion

All lenses suffer from this, but it's particularly apparent with very short focal lengths (wide-angle lenses). Vertical and horizontal lines bow outwards, especially around the peripheries of your frame.

When photographing people this leads to the features or limbs closest to the lens becoming distorted. The effect looks horribly gimmicky when attempting humour. But when used for dramatic effect it can be very powerful (see p.13). For this reason, it's a technique loved by photojournalists.

ON YOUR CAMERA:
Four thirds: >40mm
APS-C: >50mm
Full Frame: >70mm
6x6 Medium Format: >120mm
4x5 Large Format: >240mm

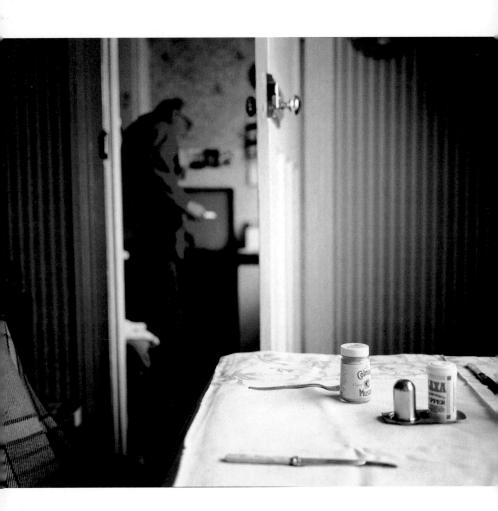

My Uncle's Home
Donovan Wylie
1998

Environmental concerns

Picture someone you know, whether it's a friend, family member or work colleague. Now think about the objects they choose to surround themselves with.

What's that thing they always carry with them? Do they keep their car in pristine condition or is it filled with junk? What sits on their bedside table? The question of environment, or context, is one of the most fundamental you need to address when photographing people.

Do you make the environment an important part of your portrait or strip everything away?

Take this photograph by Donovan Wylie. It shows his uncle pottering about the kitchen, but the shallow depth of field (see p.40) reduces him to nothing more than a blur in the background. Our attention is instead drawn to the table setting in the foreground.

This small contextual detail says so much. It tells us about his uncle's values, lifestyle and day-to-day routine. I can even hear the dinner conversation. All this from a jar of mustard!

CONTEXT

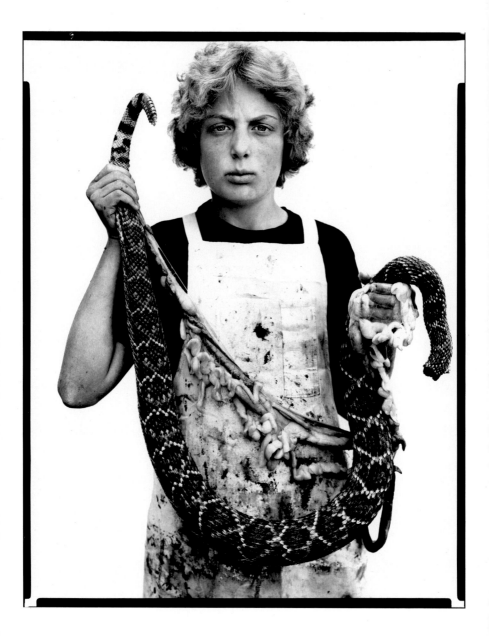

Out of this world

Photographed against a white backdrop, any visual clues as to the whereabouts of this encounter and the circumstances leading up to it have been surgically removed from this portrait like the innards of that snake.

For his series 'In the American West', Richard Avedon travelled to small-town backwaters and isolated ranches in search of the true West. A West occupied by people far removed from the mythical cowboys seen in movies. With him, Avedon carried a white backdrop, which he pinned to the outside of buildings to create a makeshift studio.

A plain backdrop separates your subject from the world and holds them up for inspection.

By placing someone against a plain backdrop you remove all contextual evidence. This elevates your subject and channels all the viewer's attention on to them. Therefore, it's a technique that should be reserved for subjects worthy of our full attention.

Avedon looked for striking individuals among the uncelebrated workers of the West and photographed them using the same clean aesthetic that he employed in his studio portraits of celebrities. Isolated against white, theirs is a beauty derived not from styling and social status, but the stuff of real life.

For other examples:
Philip Haynes p.34
Bettina von Zwehl p.60
Jemima Stehli p.72
Hendrik Kerstens p.113

Boyd Fortin, Thirteen Year Old Rattlesnake
Skinner, Sweetwater, Texas, March 10, 1979
Richard Avedon
© The Richard Avedon Foundation

Become a master of *mise en scène*

For other examples:
Cindy Sherman p.14
Jemima Stehli p.72
Jeff Wall p.88
Duane Michals p.106

A woman sits alone in a clinical waiting room. On her lap is a book. The fanned pages suggest her mind is elsewhere. Behind her stand two lifeless computer monitors and beyond that ferns can be seen through the window. Is that the outside or just another equally sterile room?

Hannah Starkey places her female subjects within carefully orchestrated environments. These 'stages' communicate a sense of ambiguity, loneliness and unease. Everything is art-directed to mirror the photographer's own feelings about living and working as a woman in London.

Make sure everything in your frame has something to say.

Starkey approaches every image as a *mise en scène*, a construction of 'coded' elements which add up to imply a narrative. Props, furnishings, colours and lighting have all been considered, to the extent that the environment feels like a character in itself.

Mise en scène also extends to how you shoot your setup. By using a deep depth of field (see p.40) you cause everything to be in focus. This gives equal importance to all elements within your frame. It makes your subject feel like they are part of the environment.

The Dentist
Hannah Starkey
2003

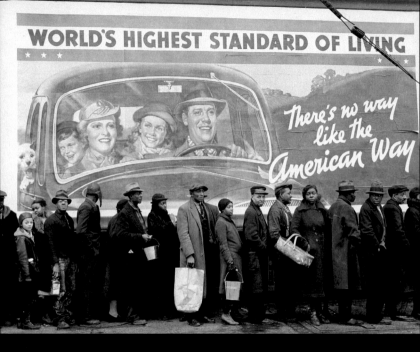

Louisville, Kentucky
Margaret Bourke-White
1937

Opposites attract

When photographing people there's no such thing as a 'neutral' environment. Context always plays its part, particularly when your subject is saying one thing and the background another – juxtaposition.

Here Margaret Bourke-White photographs a line of African Americans queuing for food after a flood. They're going nowhere fast, unlike the white family in the poster behind them, who cheerily drive their shiny new car under the slogan 'World's highest standard of living'.

Great juxtapositions need to be in-your-face.

For a juxtaposition to work, the viewer needs to get it straight away. You can't ask them to work too hard, which means nailing your composition. Here Bourke-White has filled her frame with the two essential elements: the queue of people (poverty) and the poster (affluence). Nothing else dilutes her message.

You have to train your eye to spot juxtapositions. Start with a list of opposites – rich/poor, East/West, fat/thin. Then head out to a location that epitomizes one of these qualities, for example, 'rich'. Spend a few hours hunting and I guarantee that a composition will surface that completes your pair.

For other examples:
Sam Abell p.13
Weegee p.81
William Eggleston p.102

Out of sight, but not out of mind

Two things make this portrait by Philip Haynes so arresting. First, there's the fact that the subject is photographed in a very specific context – he's lifting weights. Second, we don't actually see the man lifting weights. Rather, the tight framing around his face focuses all our attention on his fascinatingly animalistic expression.

For other examples:
Cindy Sherman p.14
Will Steacy p.37
Luc Delahaye p.48

What you choose to exclude is just as important as what you choose to include.

Context may well be important to the concept of your portrait, but this doesn't necessarily mean you need to show it. It's often enough to hint at the context, whether that's with a well-chosen title or subtle visual clues within your portrait.

It comes back to the question – *what am I trying to capture with my portrait?* For Haynes, he wasn't interested in weightlifters per se. He was interested in how the activity transforms a human being in to someone, or something, less recognizable. That's why this photograph is all about the face.

The Crossfitters
Philip Haynes
2013

Human traces

For other examples:
Donovan Wylie p.26

For his series 'Deadline', Will Steacy documented the decline of a once-thriving newspaper, now struggling to stay afloat in an online world. Interestingly, many of his most intimate 'portraits' do not feature their human subjects at all, and we're left to ponder the space they usually occupy.

This desk, belonging to journalist Michael Vitez, is messy, but there's order here, too. It features the usual suspects – manila folders, a telephone, spectacles, an award, newspaper clippings and photographs – but what kind of person still uses a Rolodex in 2012?

You can reveal a lot about your subject by photographing the traces they leave behind.

When you take your subject out of the picture, everything stops, and you're left with a still life. You're still making a portrait, but rather than interact with your subject, you interact with their possessions.

It might be the way a napkin has been folded or a cupboard organized that betrays the character of your subject. To what extent you move things around for the sake of a beautiful photograph is up to you. Just be aware that if you tamper with what you find too much, you're no longer photographing your subject. You're photographing yourself.

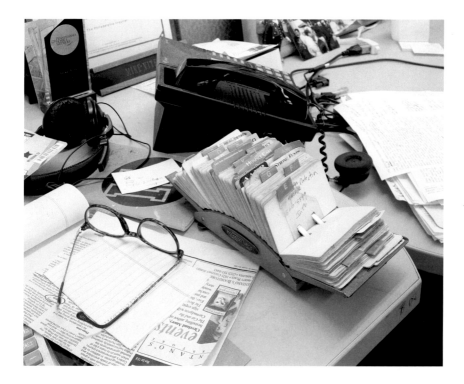

Mike Vitez's Desk, 11:14pm
Will Steacy
2012

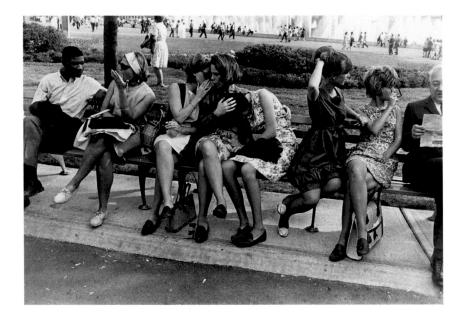

New York World's Fair
Garry Winogrand
1964

Creating your own context

A young, handsome man listens intently as his date waxes lyrical. A girl whispers gossip in her friend's ear, who is meanwhile comforting a fourth girl. Something, or someone, catches the eye of the next two girls, and finally an older man reads his paper while trying to keep hold of his spot on the bench and his place within the frame.

Garry Winogrand created this scene. That's not to say he set it up using actors. He created it by putting a frame around a section of what he saw and severed it from the world by pressing the magic button.

The photographic frame is a supercharged space which creates its own context.

When you take a photograph you create an isolated, two-dimensional fragment of the world. This concentrated frame draws connections between unrelated objects and people. Connections which don't necessarily exist in reality. It's your job to see these connections even when they are being drowned out by the rest of the world.

By putting a frame around this gaggle of girls and their two male bookends, Winogrand makes them all reliant on each other. His flat, rectangular world is like a circuit board – remove one element and the electricity no longer flows.

For other examples:
Margaret Bourke-White p.32
Henri Cartier-Bresson p.76
Weegee p.81

Aperture and depth of field

The aperture is a hole in the lens which you can make wider (more light enters) by selecting a low 'f-number', or narrower (less light enters) by selecting a high 'f-number'.

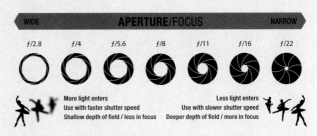

Aperture is so relevant to photographing people because it controls depth of field. A low f-number creates a shallow depth of field, meaning less of your image will be in focus. This brings your subject forward against a soft background (see p.67). A high f-number creates a deep depth of field, meaning more of your image will be in focus. This draws attention to the background and surrounding environment (see p.31).

Prime lenses (those fixed at one focal length) offer wider apertures than zoom lenses, such as **f1.8**. This makes them great for more classic portraits, as you can achieve a really shallow depth of field. They're not too pricey either, so if you haven't already got one, maybe look into buying a prime lens with a standard or slightly long focal length.

Aperture Priority (A or Av)

Your camera's portrait 'Scene Mode' 🏃 is rubbish.
It's a gimmicky preset that gives you no creative control. When it comes to photographing people, the best mode to use is Aperture Priority (**A** or **Av**).

Aperture Priority is a semi-manual mode that puts you in control of aperture, while your camera automatically finds the correct exposure by adjusting the shutter speed (see p.90).

Simply select **A** or **Av** on your mode dial. Then scroll through the f-numbers one way or the other, depending on whether you want a deep or shallow depth of field.

Exposure Compensation

Your camera club compadres may tell you that Manual mode (**M**) is the be-all and end-all of photography. Manual is helpful if you want to override what your camera's exposure meter is telling you and make your picture underexposed (darker) or overexposed (brighter). But if the ins and outs of exposure haven't yet become second nature, stick to Aperture Priority and use Exposure Compensation ☒ to achieve the same effect.

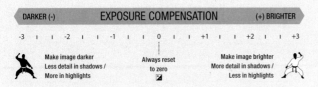

By scrolling to the **+** you'll make your portrait brighter. This will lighten skin tone and lift more detail from the shadows. By scrolling to the **−** you'll make your portrait darker. This will darken skin tone and reveal more detail in the highlights.

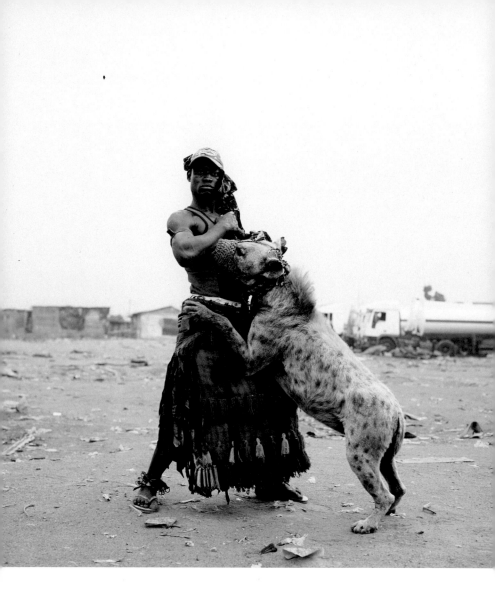

*Abdullahi Mohammed
with Mainasara,
Ogere-Remo, Nigeria*

Pieter Hugo

2007

Making eyes

A candid photograph, one where the subject is seemingly unaware of the photographer's presence, often carries a greater sense of 'truth'. We feel like we're seeing the person in their natural state. It's as if we're getting a glimpse of who they really are.

A posed photograph, one where the photographer has positioned the subject in a certain way, is very different. Subjects become complicit in the act of being photographed. We're not seeing them as they are, but rather as they are when being photographed.

Photographing people results in a tense power play of gazes between subject, photographer and viewer.

In his series 'The Hyena and Other Men', Pieter Hugo followed a troupe of Nigerian street performers as they travelled from village to village with their animals. Unfamiliar and full of otherness, the men in Hugo's images stare right back into his lens and hold their own to the point of intimidation under the scrutiny of our gaze.

Never underestimate the power of your subject's gaze. If you ask them to look into your camera they, in turn, look right back at the viewer. This returned gaze sets up a confrontation between the subject and viewer. In Hugo's portraits, both hold their own.

Blending in

For other examples:
Ed Clark p.10
Sam Abell p.13
Garry Winogrand p.38

The men in this photograph must have known of William Gedney's presence, but he's captured a moment when all five are totally absorbed in the matter at hand.

The central figure, as skinny as the piece of wood supporting him, kicks at an old motor like it's a dead animal by the side of the road. The boys, probably his sons, slouch with their heads down and listen to their old man's mumbled words. And look at how the position of each figure creates a rhythmic flow from left to right.

To capture people in their natural state you have to remain unobtrusive.

Candid photography relies on the power play between subject, photographer and viewer to be weighted towards the latter two. Here the photographer looks at the men. We look at the men. But the men don't look at us.

Achieving this is a question of time and space. People need to get used to you being there. That can take time and can't be rushed. Then it's about giving your subject(s) just enough physical distance so they forget you're there, but not so much that you, and we the viewers, feel like uninvited onlookers.

Look at Gedney's position in relation to his subjects. He's both a part of the group and apart from them. This is the sweet spot of candid photography, the place where you become invisible.

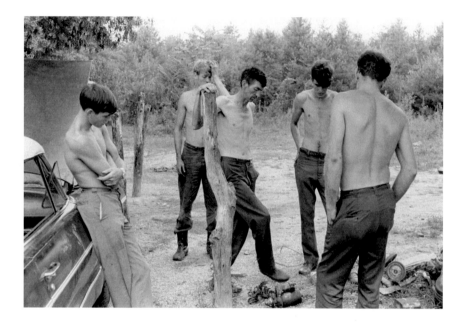

*Cornett family men and
boys stand around a pile of
car parts; one leans on a wood
pole while another leans on a
car with its hood up*

William Gedney

1972

Look for that look

In the early decades of the twentieth century the German photographer August Sander set about making an all-encompassing social documentary record of his fellow countrymen.

Sander's categorization of people, which included 'The Farmer' and 'The Woman', may seem antiquated now, but he photographed everyone with the same level of respect. Subjects were pictured in their everyday surroundings, wearing their everyday clothes. Almost all looked directly into the lens and very few smiled.

Don't let your subject hide behind their smile.

A smile put on for a photograph is a mask. They're just a little self-conscious and phoney. Instead, wait for your subject's 'default' expression: the look that only they give when they're not aware of looking or being looked at. You'll see it once their energy levels drop, so take your time, keep things calm and don't rush the shoot.

It's this man's earnest expression that tells us about a lifetime of toil. The seriousness of his gaze reveals something of him, but also challenges us. 'This is me', he's saying, 'but who are you?' In Sander's photographs no one is just 'The Farmer'.

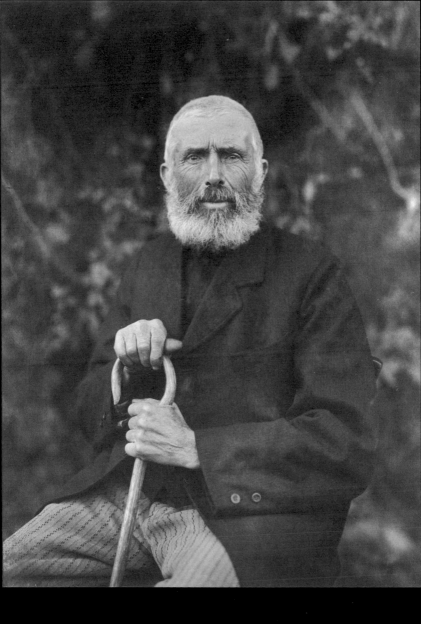

Farmer, 1910
August Sander

What are you looking at?

For examples of 'default' expressions one need look no further than Luc Delahaye's photographs taken on the Paris Metro with a hidden camera.

Sitting opposite his subjects, Delahaye surreptitiously snapped portraits of people who were totally shut off from the world around them. As they sit there, staring at anything but another human being, these men and women seem blinded by the intensity of their own thoughts. It's as if their lack of visual interaction with anyone else is a trance-like exercise in self-preservation.

A hidden camera pushes the morality of photography to the extreme.

More so than any other genre of photography, portraiture is fraught with concerns over morality. These concerns usually stem from the basic right to look and to be looked at.

Is it right to photograph people without their knowledge? How should you behave when taking someone's photograph? Where do you draw the line between public and private? Some of these boundaries are defined by law, others by you (see pp.56–59).

When photographing people, always be very aware of the moral implications of your practice, if for no better reason than to defend yourself, and your pictures, if necessary.

For other examples:
Keizo Kitajima p.8

Where to look

There are so many reasons why I'm fascinated by this portrait by Joel Sternfeld. There's something about the location, the warm light, the way the man is lightly holding his cigar but tightly gripping his child, their blond hair, the androgyny of youth and the tightness of those shorts.

But most of all I'm fascinated by their gazes. The man looks into the camera. His gaze makes a direct connection with us, which gives him confidence and locates him very much in the 'here and now'. Meanwhile, the child (perhaps a girl) looks off-frame. Her subtly elevated gaze takes her somewhere else. In this case, it's as if she's looking into the future.

An off-frame gaze removes your subject from the moment.

By asking your subject to look away from the camera you break the direct connection with the viewer. This shifts the viewer's attention away from the subject and on to what they might be thinking.

The daughter's off-frame gaze injects an element of uncertainty here. While their landscaped, Middle American driveway may offer them sanctuary, in a 'brave new world' kind of way, one wonders what the future holds.

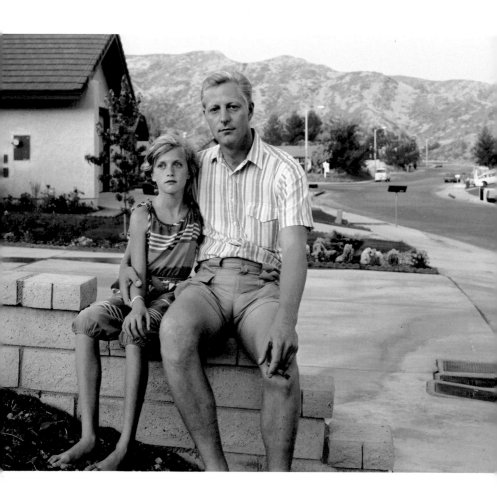

Canyon Country, California
Joel Sternfeld
1983

United or divided?

For other examples:
Sam Abell p.13
Joel Sternfeld p.51

One family member is missing from Paul Strand's group portrait of the Lusetti boys and their mother.

Killed in war, the father's absence is felt in the darkened doorway which frames his widow. She is the only one looking directly at the camera, while the varying gazes of her sons make them seem so disconnected. Is this a portrait of a family united, or one whose bond has been broken in the turbulent wake of war?

The best group portraits still capture the individuality of each subject.

The most common approach to group portraits is to ask everyone to look directly into the camera. This shared gaze unites the people within the group, but it also takes away their individuality.

Instead, once you have posed your group, let them stand there. Let boredom creep in. Let their gazes and body language wander a little. By doing this you'll capture a different kind of group portrait, one made up of individuals rather than faces in a crowd.

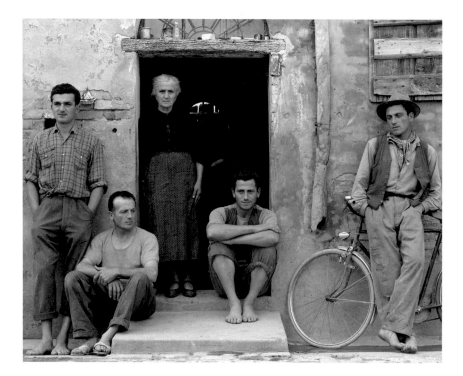

The Family, Luzzara, Italy
Paul Strand
1953

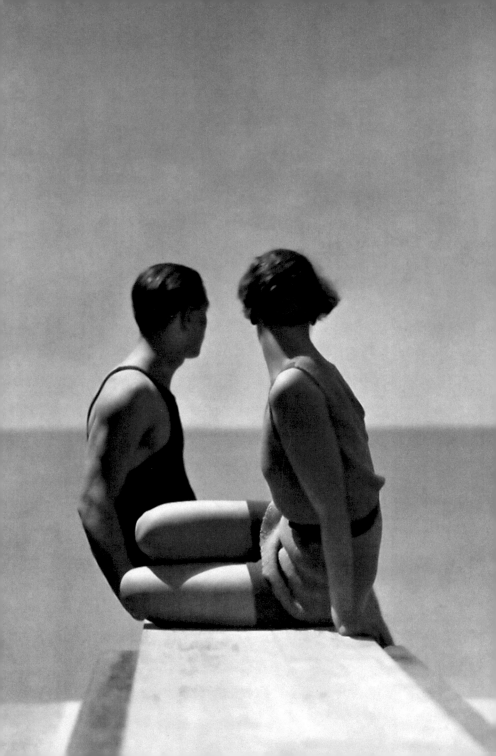

Look away now

These two divers may look like something out to sea has caught their attention, but they are in fact staring at a simple backdrop on the roof of *Vogue's* office building in Paris.

Even though I've given the game away, it's still easy to lose yourself in the illusion of George Hoyningen-Huene's photograph. With their heads turned away from us our natural desire to know what the subjects look like is denied and instead we become more interested in what they might be looking at.

Nothing in the rulebook says your subject needs to face the camera.

When a subject faces the camera and looks out from the photograph, whether directly at the viewer or off-camera, our gaze is effectively batted back by theirs. It means we only penetrate the picture so far.

But when a subject is turned away from the camera and looks into the photograph, something peculiar happens. Our gaze isn't deflected back. Instead we travel deeper into the picture by vicariously looking through the eyes of the subject.

When experimenting with this technique, don't feel that your subject actually has to be looking at anything in particular. It's less about being literal and more about creating a distinctive atmosphere through unanswered questions.

For other examples:
Mike Brodie p.98
Fred Herzog p.116

The Divers, Paris
George Hoyningen-Huene
1930

The eyes of the law

It's important to be aware of the moral boundaries when photographing people, but even more important to be aware of the legal boundaries. I asked Owen O'Rorke, a specialist in media and intellectual property law, to set us straight on where we stand legally when photographing people.

WHEN SHOULD I OBTAIN A SIGNED MODEL RELEASE?

In commercial photography (such as fashion shoots and advertising) the safest answer is 'always'. But if the model consented to a shoot, and especially if money changes hands, then in most countries the existence of a licence will be implied without a release.

The thornier issue is ensuring that everyone understands the purpose of the photograph's usage. For commercial deals, the more detail in the release the better. Start by asking for royalty-free, perpetual, irrevocable usage covering all media worldwide, re-assignable by you. It can be negotiated downwards from there!

However, with amateur subjects it is better to make the basic terms as clear and fair as possible: just state what the photograph is for and that the subject consents to both the photograph and its intended usage.

Having a signed form is helpful, but the context of the release is as important as its content. If you obtain it under pressure, or try to take too many rights by stealth, you may have issues enforcing the 'contract' later. And contracts without payment are always vulnerable.

BUT SURELY PHOTOGRAPHERS LIKE GARRY WINOGRAND WEREN'T CHASING PEOPLE DOWN THE STREET WITH MODEL RELEASES?

Garry Winogrand was operating in a different era. Not only are legal concepts of 'personal' rights developing – privacy in the EU, personality rights in the US – but ordinary members of the public are getting more savvy about them. Also, the internet means that images can really get around, and people are getting more attuned to having them taken down.

But don't panic: that doesn't mean this kind of street photography is no longer possible. There is no clear right, on either side of the Atlantic, for people in public spaces *not* to be photographed. Nor would there necessarily be any basis for them to reclaim money from you, or dictate how an image can be used, unless the image is exploited industrially – for example, prominent use on products or in advertising, where the question of endorsement arises. This type of use may be distinguished from when the image is being syndicated to a newspaper, published in a book or sold in a gallery, but there still may be issues of privacy or defamation. And be aware that people in the public eye will have greater sensitivity, as well as deeper pockets.

SO, WHAT ARE THE RISKS WHEN PHOTOGRAPHING 'ORDINARY' PEOPLE?

There are civil and criminal bases to claim for harassment, which is something any 'street' photographer should be aware of. And it is possible for a photograph to be defamatory – if it unfairly (or worse, dishonestly) places someone in an incriminating or damaging context.

That does not mean you have any obligation to make the photograph *flattering* – far from it. But the risks here might not be immediately obvious. An example might be if you photograph someone in a street scene with drugs or sex workers, and they turn out to be a community worker. The subject's first port of call might be to sue the website or paper which publishes your picture, but the publisher may in turn have an action against you.

If you identify such a risk to the image, seek an on-the-spot release form. Where this is not practical, you must make a smart decision based on risk, and be confident you are proceeding in good faith (which may assist your future defences). If you are worried that it may be invasive or defamatory, it may be best to consult a lawyer.

DO DIFFERENT RULES APPLY WHEN PHOTOGRAPHING CHILDREN?

Absolutely. For child models, consent is required from the parent or guardian. Even in public, children are generally more protected by the courts, press codes, privacy law and so on. A candid street shot of a child may have artistic merit, but a newspaper or magazine would be ill-advised to publish it without parental permission. Likewise, you may be at risk when publishing a photograph of a child online, via your website, social media or in an online gallery.

Selling such an image privately, or through a gallery, is lower exposure – both in terms of actual risk (as fewer people will see it) and liability (as a less blatant invasion of privacy). To an extent, the commercial risks are common sense. A street kid in a favela is hardly likely to see an image taken of them, still less get a lawyer – but the moral question is still relevant.

WHAT IS THE DEFINITION OF A 'PUBLIC SPACE'? (IS A BAR A PUBLIC SPACE, FOR EXAMPLE?)

The legal test in the UK (similarly across Europe) does not mention the word 'public', but focuses instead on what is 'private'. The test is: does that person have a reasonable expectation of privacy in the particular occasion being photographed?

For example, a bar is open to the public, and a home is not; but a subject may be more protected (by law) from intrusion by camera at a private function at a bar than if they let strangers into their home for a wild house party. Much depends on the nature of the act or event being photographed, as well as the location. This is a question that is still keeping lawyers busy.

CAN THE POLICE OR A MEMBER OF THE PUBLIC CONFISCATE YOUR CAMERA OR MAKE YOU DELETE A PHOTOGRAPH?

In normal circumstances, the answer should be 'no': a justifiable basis to do so is rare. But the practical experience of many photographers may tell a different story.

In most nation states, police have powers to take certain actions if they have a good-faith reason to believe it will assist in the prevention of a crime. Such an offence might include trespass or illegal surveillance, or a threat to national security. This can be extended (for example, in the UK) to a belief that the camera in question contains important evidence.

Likewise, a member of the public may have a defence for a possible crime of their own – such as grabbing or breaking your camera – if they had the same belief.

Getting compensated, or your property back, may turn out to be a frustrating experience but any citizens' advice bureau should be able to assist you in the process. Make sure to get the name, number and details from any policeman involved (and a receipt).

ARE THERE ANY LIMITATIONS ON THE IMAGE IF BRAND NAMES ON CLOTHING ARE VISIBLE?

A trademark is generally not infringed if its use is incidental or honest and does no more than identify the goods concerned. So for most artistic or journalistic uses, you should be fine if marks or names are visible in your shot, but wider commercial use of such images would be very risky.

Owen O'Rorke is a specialist in UK media and intellectual property law at Farrer & Co and deals in both contracts and legal complaints from all sides of the Rights debate.

Please note that all cases will be dependent on the facts, and the above does not constitute legal advice, but represents discussion and guidance as to the present state of the law in general terms. Different jurisdictions will apply the law differently. If in doubt, always seek legal advice.

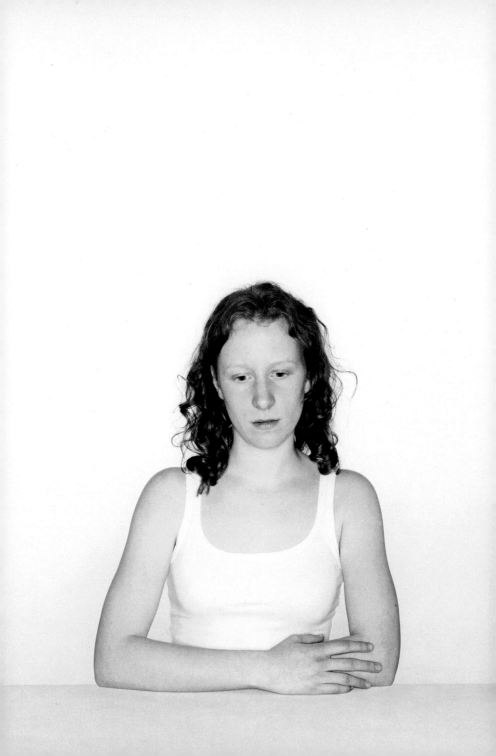

Know what buttons to push

CONTROL

When asked how they capture revealing or seemingly truthful portraits, photographers often say something like, 'It's important that my subjects are relaxed. They must feel comfortable with me.' That's all fine and dandy, but there's another way to break through your subject's facade.

By employing elaborate techniques – anything from the very subtle to the playful to the borderline cruel – you strip away people's socially learnt behaviours and expose a more truthful side of their personalities that they usually repress.

Portraiture is not always a case of making your subject feel comfortable.

For her series 'Alina', Bettina von Zwehl made women sit in a pitch-black room and listen to 'Für Alina', a highly emotive piece of classical music. During the sitting, von Zwehl would unexpectedly fire a blinding flash and capture the portrait. The flash fired so quickly that the subjects didn't have time to react, meaning they were recorded in a state of deep, solitary contemplation. In many respects, they were still alone in the dark.

To be a great portrait photographer – especially if you like posed portraits – you have to be a master of manipulation. You need to know how to interact with your subject to get exactly what you want.

No. 5
from the series 'Alina'
Bettina von Zwehl
2004

Exposing the subconscious

For other examples:
Philip Haynes p.34
Gillian Wearing p.87

During long, formal shoots Philippe Halsman would sometimes emerge from behind his camera and, with calculated coyness, ask his celebrity subject to jump.

Halsman believed that when someone jumps, their unconscious mind takes over and they revert back to what comes naturally. In some cases subjects would hug their knees and curl up into a foetal-like ball. In others they would make a desperate reach for the sky, as Robert Oppenheimer, the creator of the atomic bomb, does here.

A great photographer is like a psychologist who knows how to coax the truth from a patient.

To 'get' something from your subject, you have to maintain control while earning their trust. By giving them something playful to do – like jumping, doodling or holding their breath – you take their mind off the act of being photographed. This also helps to build rapport, especially if you join in too.

Halsman's simple request would have taken his subjects by surprise – presidents and members of the Royal Family don't 'jump' for anyone! But they all did. And why wouldn't they? After all, Philippe seemed like such a harmless fellow.

Robert Oppenheimer Jumping
Philippe Halsman
1958

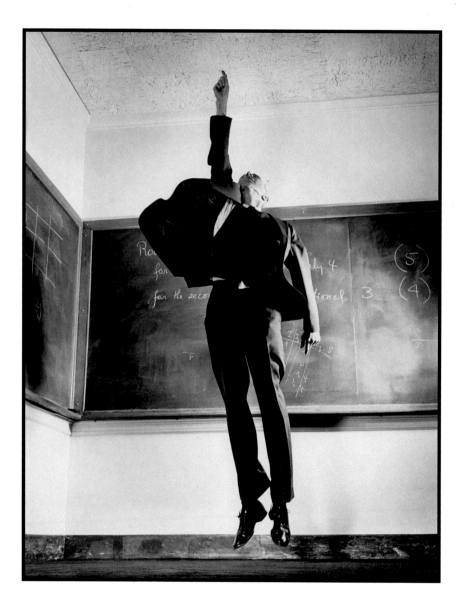

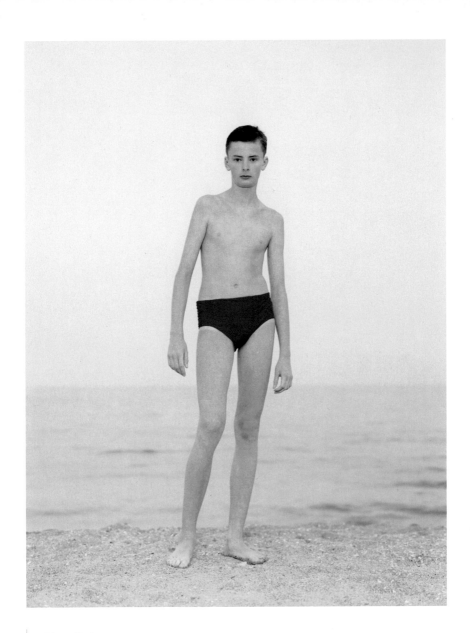

Odessa, Ukraine
from the series
'Beach Portraits'
Rineke Dijkstra
1993

The subtle art
of intimidation

Against a pale blue background of sky and water a lone boy
stands awkwardly on a beach, his pubescent limbs hanging
from his body like spaghetti. He is, of course, a willing
participant in Rineke Dijkstra's portrait, but one senses that
no great effort has been made to make him feel too at ease
in front of the camera.

Dijkstra constructs formal shoots in public spaces or following
highly charged emotional events, like childbirth, to capture
people when they feel most self-conscious and vulnerable.

For her series 'Beach Portraits', adolescent subjects were on
public view wearing only their bathing suits. Dijkstra then
photographed them slowly from behind a large format camera
mounted on a tripod and a flashgun on a stand.

Everything about how you construct and conduct your shoot influences your subject's behaviour.

Do you shoot your subject in public or private? Do you make
it quick, so energy levels remain high, or take your time and
allow them to linger in front of the lens? These are choices you
make based on what you're trying to draw out from your subject.

All this isn't about being nasty. It's about playing your role as
the photographer. And it is a role. If you're going to capture
truly great photographs of people, sometimes you need to
pretend to be someone else.

For other examples:
Paul Strand p.53
Bettina von Zwehl p.60
Jemima Stehli p.72

Posing questions

For other examples:
Philippe Halsman p.63
Rineke Dijkstra p.64
Jemima Stehli p.72

I wonder how these two people know each other? Perhaps they're neighbours or work colleagues? Or maybe a random, life-changing event brought them together? There's just something about their pose which doesn't seem to sit right.

There is, in fact, no relationship between them. For his project 'Touching Strangers', Richard Renaldi entices people on the street out of their comfort zone by asking them to pose intimately with someone they don't know. The results are intriguing. Some people manage to look like old friends, while the body language between others is more complicated.

Don't suppress your subject's physical nuances. This is what makes them who they are.

There are rules in portraiture about how your subject should stand, what they should do with their hands, and so on. These rules are fine for corporate headshots, because they're designed to remove any trace of a person's individuality. But that's not what we're about, right?

Here, rather than turning his subjects into someone they're not, Renaldi does the opposite. The awkwardness of the forced situation draws out something very personal from the people he photographs. What their body language inadvertently reveals is their ability (or inability) to relate to strangers.

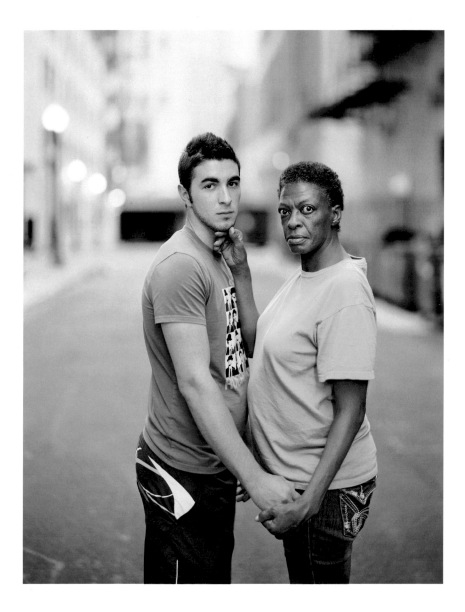

Andrea and Lillie:
Chicago, Illinois

Richard Renaldi

2013

Self control

In this, one of the earliest known self-portraits, Hippolyte Bayard photographs himself bare-chested, pale and seemingly left to rot, in order to express his anguish at being overlooked as one of the key inventors of photography. That honour had instead been bestowed upon another Frenchman, Louis Daguerre. But all was not lost, as Bayard's 'death' ultimately gave birth to what seems to be photography's current *raison d'être* – the selfie.

Really, the only subject you can have complete control over is yourself.

At first, the idea of photographing yourself might seem a bit strange. But don't think of it as photographing yourself. Rather think of yourself as a puppet on a stage, which you can control and construct to say exactly what you want.

In fact, the most enduring self-portraits are rarely just about the person in the picture. They speak about wider issues. Bayard's self-portrait still resonates after two centuries because it's not just about him. It taps into one of the most common social anxieties. The fear of being forgotten.

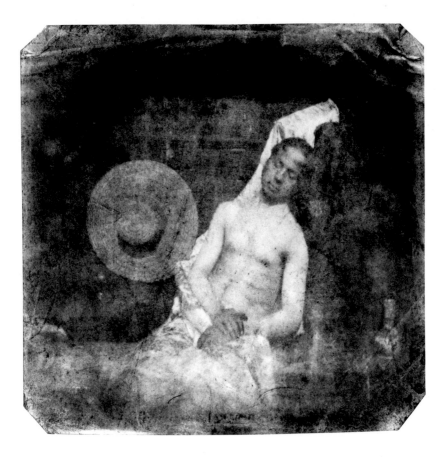

*Self-Portrait as a
Drowned Man*
Hippolyte Bayard
1840

Keep it the same, but different

He looks like a prisoner, and in a way he is. Imprisoned by his own doing. Every hour on the hour for an entire year Tehching Hsieh 'punched in' to a clock mounted on the wall of his studio and then took a picture of himself.

You might think, 'What's the point?' – but that is precisely the point. By undertaking such a futile task of his own volition, Hsieh touches on the idea that, for many, life is a never-ending, inescapable routine of work without reward.

Consistency is the key when photographing a subject over time.

Hsieh offers us a different take on the idea of control. The success of the work lies in its rigid consistency – one self-portrait taken every hour for one year. Each portrait shows the clock on the left and Hsieh on the right, the only variation being the length of his hair, which he intentionally shaved at the start of the project to highlight the passing of time.

If you're photographing the same subject over time, you need to keep things consistent. By sticking to a 'conceptual framework', or rulebook, you emphasize the changes in your subject, rather than the changes in your technique.

For other examples:
Duane Michals p.106

One Year Performance
Tehching Hsieh
1980–81

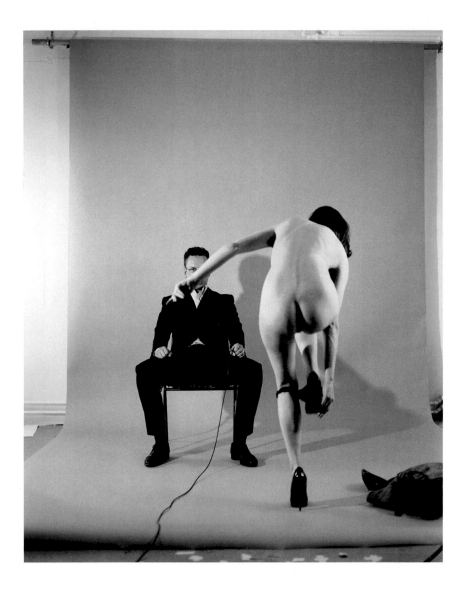

Strip No. 5, Dealer
Jemima Stehli
1999

Who is calling the shots?

For her series 'Strip', Jemima Stehli invited influential male figures from the art world in to her studio where she would then undress. As she removed her clothes the men took pictures. But in so doing, they were also photographing themselves, resulting in an uneasy oscillation of power and control.

This 'Dealer' sits aggressively defiant with his black suit, clenched fists and spread legs. But the moisture on his brow and the fact that he's chosen to take the picture when his face is partially hidden tell a different story.

The photography studio is the ultimate arena to exercise your absolute control.

Rather than just a convenient location to take pictures, the studio is a place where you're able to create something from scratch in a very controlled environment. Lights, props, backdrops and models – they can all be exactly the way you want. In the eyes of your subject, this instantly puts you in control.

Whether they liked it or not, the men in Stehli's portraits were forced to walk into her world on her terms. She may be the one without any clothes, but who do you think was calling the shots?

For other examples:
Bettina von Zwehl p.60
Bill Brandt p.101
Hendrik Kerstens p.113

Camera psychology

Photographing people is a psychological game and your choice of camera affects the behaviour of you and your subject. When choosing your camera, don't just obsess over image quality. It's important to consider its psychological implications, too.

Camera phone

Now so common in our day-to-day lives people tend not to notice, or care, if you take their picture with a phone. After all, if you were a serious photographer, with serious intentions, you'd be using a serious camera. Tell that to the photojournalist Benjamin Lowy, who photographed the conflicts in Libya and Afghanistan using his phone for precisely this reason.

Compact system camera (CSC)

The convenient size of CSCs, and the fact that you can change lenses, make them ideal for capturing unexpected, everyday encounters. But many don't have viewfinders, meaning you have to hold the camera at a distance. In the eyes of your subject, this doesn't make you look like a serious photographer. Depending on what you're after, this amateur aura can play in your favour, or undermine your authority.

Digital single-lens reflex (DSLR)

DSLRs have viewfinders, and the act of looking 'into' your camera, rather than 'at it' (like phones and CSCs) makes for a more intimate shooting experience. But DSLRs conceal your face, which can make subjects feel like they're being preyed on. To Joe Public a DSLR is a professional's camera, so people tend to notice when one is being pointed at them in the street.

Rangefinders

Quiet, lightweight and portable, rangefinders are favoured by street photographers. Operationally, the viewfinder is located at the edge of the body, so you're able to compose your shot with one eye, while observing the whole scene with your other. This makes for a much more 'fluid' shooting experience and means you're faster and less conspicuous on the street.

Single-lens reflex (SLR) – medium format

Now we're stepping it up, not just in terms of image quality but also in terms of our professional aura. Although these cameras can still be handheld, the waist-level viewfinder and general functionality makes you take pictures in a slower, more considered way. In the eyes of your subject, if you're using an 'unusual' camera like this, you must be a photographer with an agenda.

View cameras – large format

Their unsurpassed image quality, size, and the slow, methodical way in which they make you take pictures, creates a very different shooting experience for both subject and photographer. Their size separates you from your subject physically (and sometimes emotionally). Patience is required on all fronts, as nothing happens quickly with a view camera. But stand behind one of these and there's no question that you are the one in control.

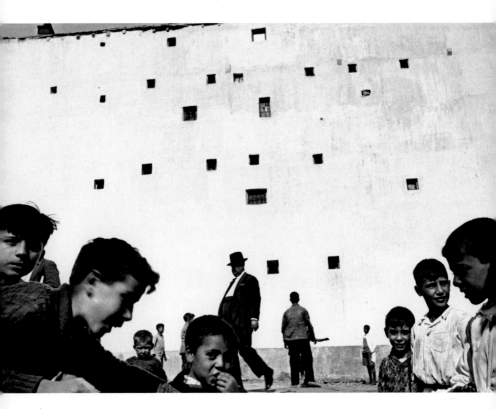

Madrid
Henri Cartier-Bresson
1933

It's out of your control

When cameras became smaller a photographer's world became a whole lot bigger. Armed with their discreet magic boxes, photographers began tiptoeing through city streets, recording an alternate reality of beautifully ephemeral human moments.

Here, one of the founding fathers of street photography, Henri Cartier-Bresson, shows us exactly what he means by his phrase 'the decisive moment'. Different-sized windows float up above the hubbub like an assortment of musical notes. As if weightless, a fat man bobs into the centre of the frame. Among the medley of children a single boy meets the eye of the photographer – he gets the joke.

Capturing fleeting moments on the street is all about making your own luck.

You always have to be one step ahead, analyzing and anticipating the world as it unfolds around you. Travel light: no tripod and no bulky kit bag. Train your eye: see people 'within' the context of the foreground, middle distance and background. Be agile: when you spot something, seize the moment like your life depends on it.

Cartier-Bresson's approach still lies at the heart of most street photography, but, just like the photographers we're about to see, you can mould and adapt his technique as you pursue your own equally distinctive photographs of people on the street.

THE STREET

Assault your subject

Bruce Gilden's approach to photographing people on the street stands in complete opposition to Cartier-Bresson's. With Gilden, it's less a case of chancing upon a scene and much more about creating it for himself.

Attracted to New York's oddballs and eccentrics, Gilden pounces on passers-by, hits them with a dizzying flash and snatches their picture like a mugger. That's why these two characters look like they've been captured riding a rollercoaster rather than walking down Fifth Avenue!

Allow your own personality to feed into your portraits.

Some prefer to prey on their unsuspecting subjects from afar – snipers. Others get closer and like to establish some kind of connection – undercover agents. Then there are those who dart in, shoot up close and make off – assassins.

Gilden thrives on the excitement of taking people by surprise. It's what gets him up in the morning. It's what gives him the motivation to keep shooting. Ultimately, it's what makes his work so individual. By understanding who you are and what makes you tick, you'll discover your own unique way of photographing others.

New York City
Bruce Gilden
1990

Shooting fish in a barrel

For other examples:
Luc Delahaye p.48
Robert Doisneau p.82

They called him 'Weegee', as in Ouija board, for his apparent psychic ability to predict photo opportunities. In his case, the aftermath of grizzly murders on the streets of New York.

In this photograph, morbidly titled *Their First Murder*, Weegee captures a whole gamut of human emotions. As a frenzy of wide-eyed youngsters fight to get a glimpse of the gory details their excitement smothers the anguish of an inconsolable woman. And if that questioning look we're getting from the kid in the foreground is anything to go by, then we're no better than the rest of 'em! The perverted onlookers of the perverted onlookers.

Decisive moments are at their most plentiful when everyone is guilty of gazing.

Some photographers are happy wandering the streets in search of their decisive moments. Others go directly to the hotspots – public events and spectacles. These are the places where your potential subjects are so distracted they either don't notice or don't care that you're taking their picture.

Weegee had a moth-like attraction to crime scenes because he knew what he would find there: a captivating sidewalk drama of law and disorder made up of police, public and perps. Psychic ability maybe – but the police radio he kept in his car probably also helped.

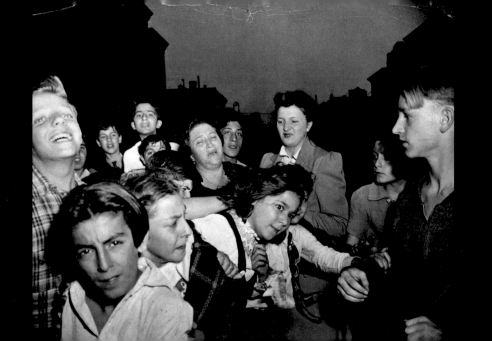

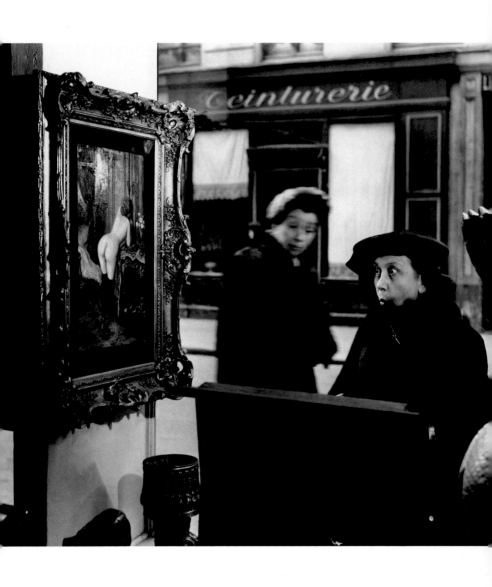

Be ready and waiting

It took a brave Parisian gallery owner to place such a saucy painting in his window in the 1940s. It was just a matter of time before it would catch the disapproving eye of a prudish member of the public.

For Robert Doisneau this created an irresistible photo opportunity. Setting himself up inside the gallery and out of sight of the passers-by, Doisneau composed his photograph in advance, positioning the painting on the left and what would have been an empty window on the right. Then all he had to do was wait.

Find the right spot and all the action will come to you.

People are constantly interacting with urban spaces in the strangest of ways. Waiting in one spot allows you to set yourself up in advance, so that you're ready and waiting for the action when it unfolds in front of your lens. It's a technique as old as street photography itself.

Stairways, billboards, street corners, pedestrian crossings, obstructions in the road: all these make perfect backdrops and stages. And best of all, your unsuspecting subject won't even know they're part of the performance.

For other examples:
Otto Steinert p.85

The Offended Woman
Robert Doisneau
1948

Ongoing moments

In Otto Steinert's photograph the tree appears pin sharp, as indelible as the many years it has spent slowly growing in that one spot. In contrast, a passer-by – transient, always on the move – appears as a blur, his foot only discernible as it makes contact with the ground before being uprooted by his haste.

Use slow shutter speeds to capture a sense of time passing.

More often than not, photographers choose to freeze the hustle and bustle of people on the street. This creates abstract, singular moments. By blurring people's movement you create a different kind of moment, one that seems elongated.

You'll start to see signs of blur with shutter speeds slower than **1/60** and the slower you go the greater the blur (see p.90). Avoid camera shake, as Steinert has done here, by using a tripod.

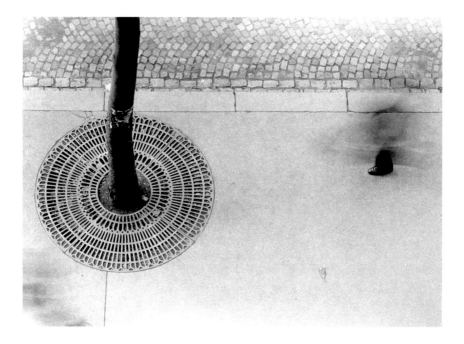

A Pedestrian
Otto Steinert
1950

Straight shooting

For other examples:
Richard Renaldi p.67
Robert Bergman p.121

The brilliance of this idea lies in its simplicity: approach complete strangers on the street. Ask them to write down what's on their mind. Photograph them holding up their sign.

Shocking, tender and always revealing, Gillian Wearing's portraits cut through her subject's public masks to expose their innermost anxieties and desires. 'I'm desperate', says this man with a sharp suit and smug expression. Is he referring to his unfulfilled sexual needs or his finances? Either way, something significant lies behind his cry for help.

Street photography isn't always about capturing 'moments'.

Decisive moments can be beautiful, witty and electric, but they don't tell us anything about the person in the picture. It's just not possible to do that in an encounter that lasts a fraction of a second. By adopting a slower, more interactive approach, you have a far more intimate encounter with people on the street.

There are a multitude of different ways you can approach it, but, at its core, all street photography is about encountering strangers. The way you choose to do this puts you very much in the picture.

Signs that say what you want them to say and not Signs that say what someone else wants you to say.
I'M DESPERATE
Gillian Wearing
1992–93

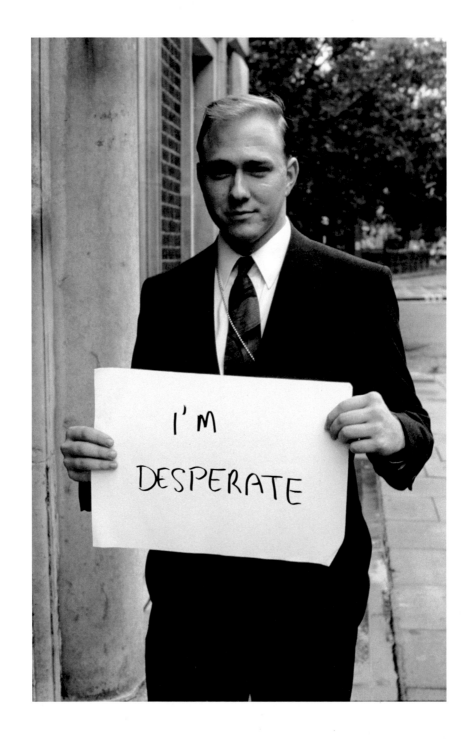

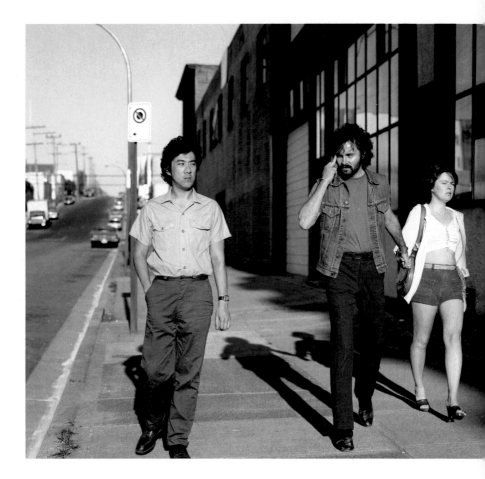

Mimic

Jeff Wall

1982

Don't worry about fitting in

Jeff Wall, with his preference for using an unwieldy large format camera, is not best placed to capture fleeting moments of people on the street. So, rather than snap moments as he sees them, Wall recreates them using actors.

This image is based on a racist incident that Wall witnessed in Vancouver. As the trio walk towards the camera, the intensity of the moment is heightened by the glare of the late afternoon sun. It's then all acutely brought to a head, and any ambiguity quashed, by the title, *Mimic*.

Blur boundaries to create something new and arresting.

Is *Mimic* street photography? How does it relate to Cartier-Bresson's 'decisive moment'? It's fascinatingly hard to pin down, and when seen in exhibition, enlarged to over two metres and presented in a light box, *Mimic* becomes even harder to place.

Defining your photographs by genre does help you get a feel for where you fit, but don't let this limit your creativity and try not to simply imitate what others have done before. This is a common trap, especially for street photographers.

As Wall so brilliantly shows us, by mixing and matching genres, styles and techniques you break free from well-established practices and uncover new and more distinctive ways of photographing people.

For other examples:
Richard Avedon p.28
Hannah Starkey p.31
Helen Levitt p.95

Shutter speed and movement

Shutter speed is the length of time that light enters your camera. Slower shutter speeds record more movement, as the shutter is open for longer. This blurs your moving subject. Faster shutter speeds capture less movement, as the shutter opens and closes very quickly. This freezes your moving subject.

With street photography you generally want to freeze people. This means you could, if you wanted, use Shutter Priority (**S** or **Tv**), as this is the semi-manual mode that puts you in control of shutter speed, while your camera automatically controls the aperture. But in this case, it's actually better to stick to Aperture Priority. Let me explain why.

As your subject is often moving towards or away from you while you're composing, you need to keep a close eye on your depth of field. A deeper depth of field (narrower aperture) reduces the risk of your subject falling out of focus (which is even more annoying than the subject being slightly blurred by a slow shutter speed or camera shake). This is where ISO comes into it.

ISO

ISO controls how sensitive your camera is to light. The higher the ISO, the more sensitive your camera. This means your camera needs less light to achieve the correct exposure. In other words, by upping your ISO you can use faster shutter speeds and narrower apertures, which is exactly what you want on the street.

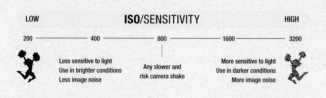

With street photography it's worth upping your ISO to around **800** because you're constantly darting in and out of shadow areas. This means your shutter speed will rarely drop below about **1/60** when on Aperture Priority. Just be aware that higher ISOs produce more image noise, so avoid anything unnecessarily high.

Your starting point on the street

So, start by selecting Aperture Priority (**Av** or **A**) and set your aperture to about **f11**. Then set your ISO to about **800** and let your camera figure out the shutter speed. If you find that your shutter speed is occasionally dropping below **1/60**, increase your ISO. That's it. Now get out there!

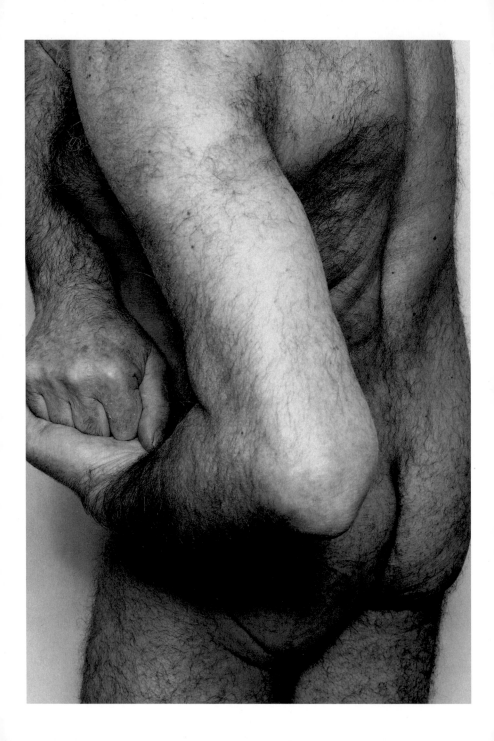

Ways of seeing

At the risk of sounding like a photo fuddy-duddy, colour has become the default of digital photography and black and white an afterthought.

Rather than shooting in colour because a subject calls for it, people tend to do so because that's how their camera is set up. And all too often people compose their shot using the language of colour and then hope that it will translate into black and white later. Neither of these approaches work.

Choosing between black and white and colour affects who you photograph and how you photograph them.

John Coplans photographs himself in black and white as a way of coming to terms with his own ageing body. The tones draw our attention to surface detail. This transforms his body into something abstract, sculptural and tactile. For Coplans, the distancing offered by black and white is an act of catharsis.

It's like tuning your eyes to a certain frequency. Colour enlivens what black and white dampens, black and white simplifies what colour complicates and where colour shocks, black and white can transform atrocity into art.

Three Quarter Back,
Hands Clasped
John Coplans
1986
© The John Coplans Trust

Colour attracts colour

For other examples:
Sam Abell p.13
Hannah Starkey p.31
William Eggleston p.102
Fred Herzog p.116

You can feel the engines impatiently revving as the little old couple take their time to amble across the road. And the matching blues of the lead car and the man's clothes make him seem even more vulnerable, instantly creating a visual connection between predator and prey.

Helen Levitt's colour photographs of people on the street not doing all that much helped to open up a new world of possibilities for photographers. Subjects that had been overlooked by those shooting in black and white were suddenly seized upon by those attuned to the vivaciousness of colour.

Make colour the subject of your photograph.

Colour offers you a visual opportunity that's there for the taking. When isolated within your frame and set against the grey concrete hues of the city, simple things like the colour of a person's jacket or hair, or the shade of their lipstick can be transformed into something playfully abstract and expressive.

Go on, head out onto the street and give it a go. But don't see a hat as a hat. Instead, see it as a splash of colour that you can build your composition around to create a real page popper.

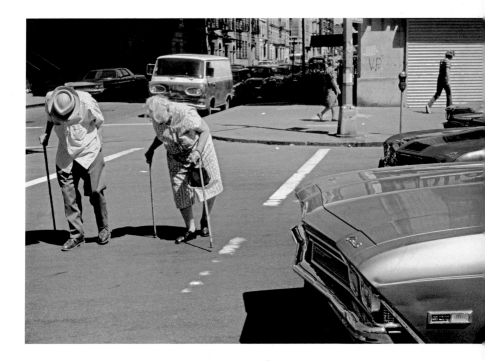

Untitled, New York
Helen Levitt
Undated

Creating mood with tone

For other examples:
John Coplans p.92

Dana Lixenberg's black-and-white portraits show us the lesser-seen side of America's young, black and impoverished. This is Toussaint, one of the residents of a neglected LA housing estate called Imperial Courts.

Sitting calmly and depicted in shades of grey, this portrait counters any negative stereotypes created by mainstream media. The soft black-and-white tones add sincerity and slow everything down. It causes us to consider this young man differently. We don't see Toussaint as an unemployed black youth who is a menace to society. We see him as a human being.

Use the subtlety of tone to establish the overall mood of your portrait.

Look closely at Lixenberg's portrait and you'll see that there are no areas of bright white and very few pure blacks. 'Black' and 'white' lie at opposite ends of the tonal range. By making use of midtones you lower the contrast of your portrait, which subdues the mood and lends your subject a more introspective quality.

You can subtly reduce contrast using 'Levels' or 'Curves' in image processing software. But really, the best way to draw out midtones is to avoid bright sunshine and instead shoot under the soft, even light of an overcast day.

MIDTONES

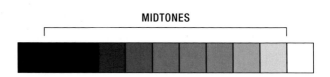

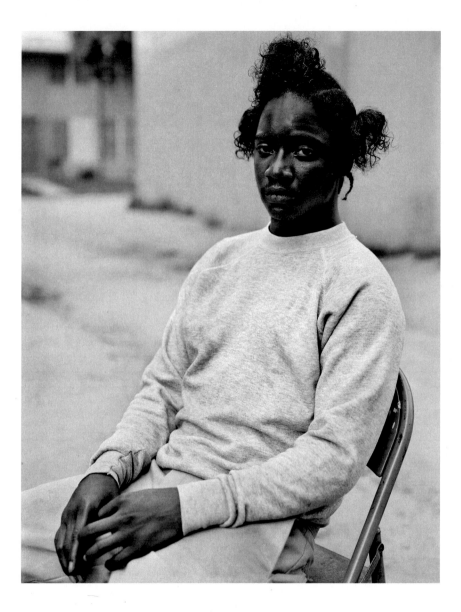

Toussaint
Dana Lixenberg
1993

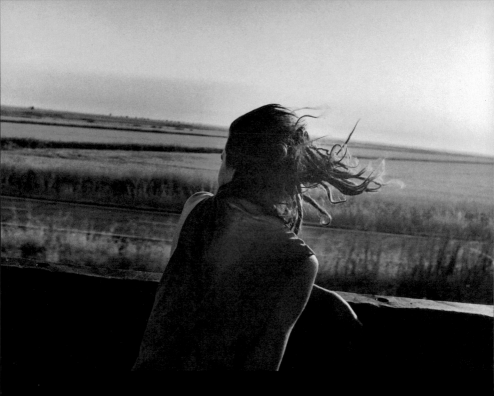

#0924
from the series 'A Period of
Juvenile Prosperity'

Mike Brodie
2006–09

Creating mood with colour

BLACK AND WHITE OR COLOUR
Warm tones

Like something from the pages of Jack Kerouac, a teenage Mike Brodie hitched rides on freight trains and journeyed across America. He travelled light, as most drifters do, only making extra room for a camera loaded with Kodak film.

Brodie's reportage-style portraits of his vagabond band of brothers are flooded with warm tones. Partly from the golden sunlight, but also from his choice of film stock (and perhaps a cheeky touch of post-processing), this warmth lends his subjects, and their shared rite of passage, a glorious sense of romantic idealism.

Warm hues project positivity and well-being. They comfort your subject like a blanket.

The colour cast of your image is something you can manipulate to say exactly what you want. Even a very subtle warmer or cooler shade fundamentally affects the mood of your picture and how your subject is portrayed.

We can't see this person's face or what they are looking at, but the warmth of the image gives us a profound sense of who they are and what they're about. Imagine if this picture were awash with cool blue. The positive, free-spirited atmosphere would be replaced by something a little more foreboding.

Adjusting your camera's 'white balance' will affect the colour cast of your image. But rather than messing around with that, it's best to set your white balance to auto (AWB) and adjust the colour later.

For other examples:
Joel Sternfeld p.51
Fred Herzog p.116
Bill Henson p.118

Creating impact with tone

Rather than concern himself with the subtleties of tone, here Bill Brandt uses hard, directional light to reduce this nude down to abstract planes of 'black' and 'white'.

Black and white strips photography back to its fundamental building blocks, that of light and dark.

Pair the reductive qualities of black and white with the high-contrast nature of hard light, and shadows become voids of black and highlights burn out to white. If your subject is a nude, this process of abstraction will ruthlessly carve up their form with what's called 'negative space'.

Negative space is the area around your subject. With black and white, this negative space can become so present in your photograph that it calls for you to build your composition around that, rather than your subject.

See here how the model's arm cuts across the frame to create beautiful triangles of black. This is what Brandt was looking at when he composed this portrait. He used this space to define the lines of the body, but made them ever-present abstract forms in their own right.

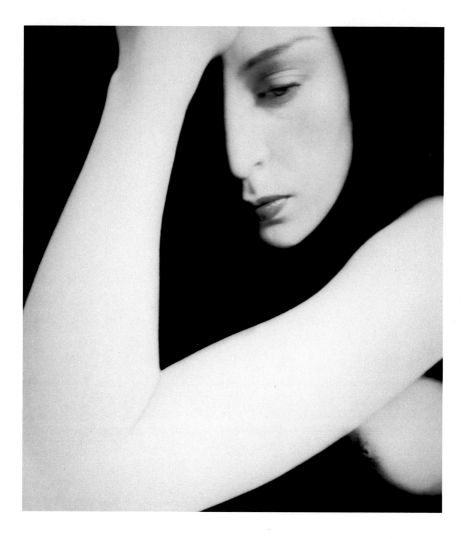

Nude
Bill Brandt
1952

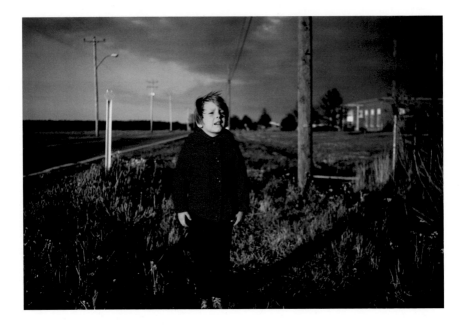

Untitled (Young Boy In Red Sweater)
from 'The Seventies: Volume Two'
William Eggleston
1971

Creating impact with colour

**BLACK AND WHITE
OR COLOUR**
Colour hierarchy

Steely blue clouds loom over the horizon. Flecks of green grass catch the last rays of sunlight before the impending storm. A boy stands in the foreground, his red cardigan resonating from the image like the roar of a tornado siren.

Against a background of greens and blues, William Eggleston's red-clad subject surges forward from the composition with an emotional charge that makes the boy bleed with vulnerability.

For other examples:
Hannah Starkey p.31

All colours provoke an emotional response, but some more than others.

Yellow can be upbeat, blue can be cool and green can be a number of things. But nothing catches the eye like red. Its carnal connotations cause it to come forward in your composition while everything else falls back into submission.

It's something to keep a close eye on when composing your photograph. It's fine if your subject is primarily red, as this will naturally bring them forward. But if they're not, and something else in your image is, then this can overpower your subject no matter how much space they occupy in the frame.

Seeing in black and white

With black and white, you need to get a feel for how colour translates into tone. For instance, red and green are obviously different in colour, but look very similar in black-and-white tone.

Filters affect how colour translates into tone and help to give black-and-white photographs more depth. Filters lighten their own colour and generally darken the tone of their opposite colour. So, a red filter will make reds appear lighter, while the tone of the opposite colour – green – will appear darker.

Original colours	No filter	Red filter	Yellow filter	Green filter
	Tones look more similar, contrast is lower	Lightens reds, darkens greens and blues, generally increases contrast	Darkens blues, generally lightens other tones, especially yellow	Lightens greens and yellows, slightly darkens reds and blues

Black-and-white conversion

If shooting with black-and-white film, then you would put these filters over your lens. It's different with digital. Rather than use your camera's black-and-white function, it's best to shoot in colour (RAW) and convert the image later using image-processing software.

Use the 'Channel Mixer' or 'Black-and-White Filter' function on your colour image file to imitate the effects of these filters by adjusting each colour channel individually.

Seeing in colour

Sometimes you see colours next to each other and just know they feel right: visual instinct. Other times, particularly when shooting models, you need to choose the clothes, backdrop and props. This is when it's helpful to know which colours go together and why.

Complementary colours

Look again at the colour wheel and you'll notice that every colour has an opposite. These are 'complementary colours' and when placed next to each other they'll really 'pop'. Using complementary colours is a great way to add energy to your images and catch the viewer's eye. Turn back one page to see this in action.

Analogous colours

For more harmonious colour relationships use 'analogous colours'. These are similar colours which lie next to each other on the colour wheel. Using analogous colours results in images which feel calmer as everything goes together. For examples, see pages 51, 118 and 121.

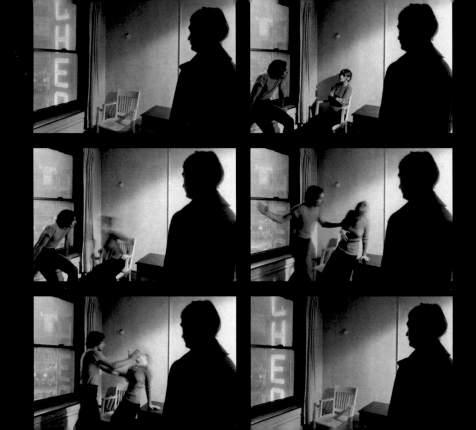

Listen to the light

On the one hand, light gives shape to physical things, like your subject's form and features. On the other, it exposes something less tangible. You can use it to reflect your subject's personality or state of mind.

It can be flattering or cruel. Intense or subdued. Constant or ever-changing. All these qualities fundamentally affect the mood of your portrait. Whether you're creating it in the studio or encountering it on the street, you need to listen to what the light is saying.

Light is never neutral. It always comes loaded with psychological implications.

Look at the light in this sequence by Duane Michals, called 'I Remember the Argument'. Inside, the hardness of the light casts dramatic shadows which transform the man into a menacing silhouette. Outside, there's a subtle transition from night to day and back to night. Here, the light is doing all the talking, but what is it saying to you?

In this final chapter we're going to return to this idea of visual instinct because, just like composition, light is also something you have to feel. Yes it needs to be measured – that's the easy part – but exposure values don't tell you anything about the 'psychology of the light'. To fully understand that you have to tap into something more primal.

I Remember the Argument
Duane Michals
1970

PSYCHOLOGY OF LIGHT

It's only natural

For other examples:
Donovan Wylie p.26
George Hoyningen-Huene
p.54

Just what is going on in Glen Erler's photograph of his
mother? That light. It pierces through the blinds like some
kind of otherworldly presence, striking her down and
rendering her immobile.

For his series, 'Family Tree', Erler uses natural light to explore
his sense of physical and emotional separation from his
friends and family back home. Daylight forms glowing pools,
subjects are obscured by darkness and shadows transform
domestic spaces into something more ominous. Erler's light
is mysterious. It comes and goes. It reveals and conceals. It
acts like another elusive member of the family.

Natural light has a presence in your image that's as tangible as a person.

Natural light is just that – natural – and it carries with it a sense
of purity. You don't create or overly manipulate it. You simply
work with what it gives you. And just like a person, it has
moods that can change in an instant. These qualities make
portraits shot with natural light feel all the more human.

Windows are a free light source which give you all sorts of
beautiful effects. Position a subject near a window at different
times of day and you'll see how the mood of your portrait
changes with the light.

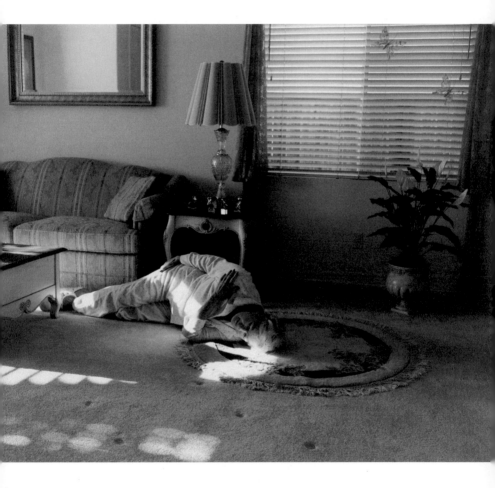

Mom Laying on the Floor
Glen Erler
2011

Cat Catcher
Roger Ballen
1998

Inside the mind of a flasher

And now for something completely different. Roger Ballen photographs South Africa's social outcasts and the mentally unhinged. When he visits them they perform for his camera against a backdrop of scarred walls, crooked pictures and exposed electrical cables.

This boy's expression is disturbingly similar to that of the cat he's gripping tightly by the scruff of the neck and that tangle of metal over his head hints at his mental state. It's a scene of bedlam that Ballen has crystallized with the brutal effects of on-camera flash.

On-camera flash is an aggressive light that 'hits' your subject from the same angle as you're shooting.

Use direct, on-camera flash – but don't take its effects for granted. This kind of flash feels like the physical embodiment of our gaze and subjects look like they are literally being attacked by light. Here the shadows have cut a shape around the boy's outline. It's as if the flash has purged his psyche from his body and pinned it against the wall.

Your camera's inbuilt flash offers you no creative control, so use a flashgun instead. If you're after brute force, attach one to your camera and point it directly at your subject. To soften its blow simply turn down its strength or bounce the light off a white ceiling.

For other examples:
Bruce Gilden p.78
Weegee p.81

The light touch

Not all artificial light has to be brutal. When photographing his daughter, Paula, Hendrik Kerstens takes his lead from the soft light of seventeenth-century Dutch painting.

Paula may resemble one of Vermeer's girls, but the usual loftiness of art history is brought refreshingly down to earth by Kerstens' playful use of everyday objects. Here she's less 'Girl with a Pearl Earring' and more 'Girl with a Bubble Wrap Bonnet'.

The most beautiful studio portraits employ the simplest lighting setups.

Kerstens' portrait exudes calmness because he's used 'Rembrandt lighting' – a particular style of lighting often seen in the work of the Dutch painter. And it's an effect that you can achieve with surprising simplicity.

Firstly look at the shadows. They tell us that the light is coming from the upper left. Their softness is the result of a diffused light source, such as a soft box or umbrella, the position of which is just forward enough to create a distinctive triangular highlight on Paula's cheek. Now notice how her back is very subtly illuminated. That's the work of a reflector, which is used to lighten shadows.

It's beautifully soft, simple lighting.

Bubble Wrap
Hendrik Kerstens
2008

What are we actually seeing?

In contrast to the previous photograph, the flat, frontal lighting used here by Thomas Ruff gives this portrait the characteristics of something taken for institutional purposes, where function forgoes artistry. The light exposes all – every pore, wrinkle and eyelash. All, that is, apart from any trace of emotional involvement from, or between, subject and photographer.

But unlike the pocket-sized portraits found in passports, Ruff's is printed monumentally large. And it's the sheer impact of detail and absence of any emotive lighting that suggests, in spite of all our efforts, a portrait can only record the surface of someone and nothing more.

If portrait photography is indeed a grand illusion then you are the magician.

Ruff uses this lighting technique to neutralize any psychological interpretation of his subject. Lit from the front, there are no shadows to give shape to the features and convey mood. In many respects, it's the most 'matter-of-fact' way to light a subject.

Ruff is essentially asking us to wise up. We may use elegant or intriguing lighting in an attempt to capture the psychology of our subject, but what are we actually seeing in the end? As photographers, we're all illusionists. We just need to find our own bag of tricks.

Portrait (S. Weirauch)
Thomas Ruff
1988

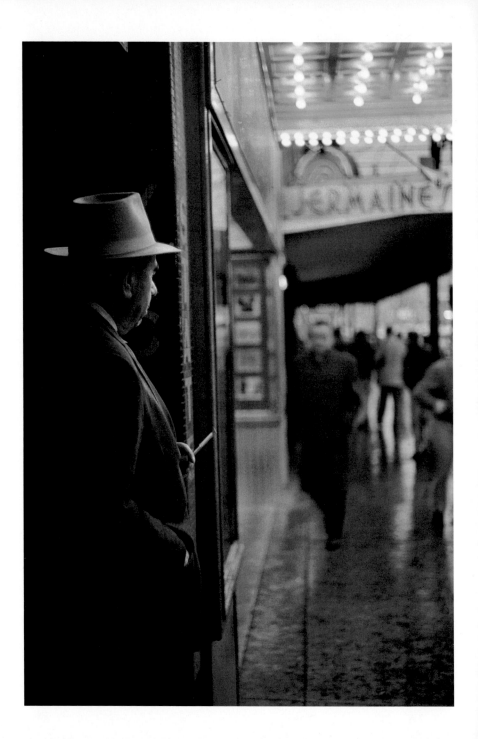

Ambient ambiguity

The man in Fred Herzog's photograph may simply be waiting for his wife, but the ambient light transforms him into someone far more intriguing. He is a *flâneur*; a lone wanderer of city streets with no purpose other than to quietly observe the activities of others.

The warm light from the movie theatre lifts his profile from the shadowy doorway. It reveals that he stands casually with a cigarette in hand, separate from the hustle and bustle seen in the cool blue drizzly daylight in the distance.

Ambient light is a gift not to be wasted.

Ambient light is at its most atmospheric when it's a mixture of natural and artificial light. Portraits can carry an underlying sense of transition – day to night, light to dark, past to future. All of which can be used as metaphors to create an aura around your subject.

Ambient light is often low light, but don't – whatever you do – try to counteract this with flash to avoid camera shake. Flash is the nemesis of ambient light. Its blanket power will burn out any atmosphere and leave you with a snapshot. Use a tripod instead. If you haven't got one to hand, increase your ISO (see p.91).

For other examples:
Duane Michals p.106
Bill Henson p.118

Flâneur, Granville
Fred Herzog
1960

Untitled, 73/120
Bill Henson
1985–86

Shadow play

This photograph by Bill Henson is a reminder that there is no light without shadow. Intentionally underexposed, the inky darkness envelops the girl, surrounding her in a musky ambiguity.

Everything about the portrait occupies a limbo land of uncertainty. The subject is neither child nor adult. She seems so distant, yet the framing is tight and intimate. She's photographed at a time of day that's neither light nor dark. And there's something about the coldness of the ambient light. Is she on a train or waiting at a bus stop? Either way, she's neither here nor there.

Exposure is a matter of opinion. Opinion informed by your instinct.

I'm sure you hear a lot of talk about 'correct exposure'. But exposure isn't a case of right or wrong. It's a personal choice informed by what you're *feeling*. Depending on the mood you're going for, you might want your subject to lurk in the darkness, while at other times you might flood them with light (in these cases, think Exposure Compensation, p.41).

Henson uses the psychological connotations of darkness and cool blues to draw us in to his portraits. Subjects recede into shadows. Making them out is like recalling a distant memory or something from a fading dream. Go on, allow yourself to be absorbed by the light a little bit more.

For other examples:
Duane Michals p.106
Glen Erler p.109

Exploring
the paradox

For other examples:
Arnold Newman p.22
Donovan Wylie p.26
Richard Avedon p.28
Paul Strand p.53
Rineke Dijkstra p.64
Jemima Stehli p.72
Dana Lixenberg p.97
Mike Brodie p.98
Roger Ballen p.110

The biggest challenge when photographing people – and I'm not talking about chasing happy snaps – is to reveal that hidden, intangible something that lies beneath.

After all, photography can only record light reflecting off surfaces. And herein lies the paradox of our medium. How do you reveal what's happening on the inside, if all you can show is the outside?

It's about fusing instinct and technique.
It's about everything working together.

Look at the different elements at play in this portrait by Robert Bergman of a sorrowful man he encountered on the street: the tight composition, the shallow depth of field, the intensity of the man's gaze, the fiery golden background, the flatness of light.

This combination of elements – the subject, how Bergman interacted with him, the surrounding context and the visual traits of photography itself, created by the lens and frame – are communicating this man's story.

To take great photographs of people you have to forgo judgement for empathy. You have to see yourself in your subject. You have to abandon logic, give in to all your senses and trust your visual instinct.

Untitled
Robert Bergman
1995

Studio lighting kit

Natural light constantly changes. Nothing can be guaranteed. But you have complete control over the artificial light in the studio. So if you're after consistency and control, studio lighting is your only option. Here's what you need to get set up:

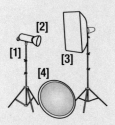

Basic lighting kit

This comprises 2x 400W flash heads with stands **[1]**, 2x dish reflectors **[2]**, 1x soft box **[3]** and 1x disk reflector **[4]**. Create hard light by placing a dish reflector over the flash head. Create soft light by doing the same with a soft box. Use a disk reflector to reflect light back onto your subject to lighten shadows if necessary.

Flash meter/sync lead

As flash heads don't offer a constant light, you will need a flash meter to figure out the exposure. On the meter set the ISO to **100** and the shutter speed to no faster than **1/250** depending on your camera's 'flash sync speed'. Hold the meter in front of your subject's face and fire the flash head(s). The meter will give you the aperture value.

Manual (M)

Your studio mode is Manual (**M**). As you're using a flash meter, your camera's internal exposure meter is redundant, so simply put your camera on Manual and set your ISO, shutter speed and aperture to whatever your flash meter tells you.

Basic lighting setups

The golden rule of lighting is to keep things simple. Use as few lights as possible and avoid lighting your subject from too many different directions. Now you know what kit you need, here are some basic lighting setups:

Rembrandt (soft box and reflector)

Position your subject so they face the light, then get them to turn their head towards the camera. Use a reflector to lighten the shadows if needed. Position the subject and light correctly and you'll create a triangle-shaped highlight on their cheek, as seen on p.113.

Split (soft box and reflector)

By moving your light further around, half of your subject's face will be lit while the other half slips into shadow. Use a reflector if you feel the contrast between the highlights and shadows is too dramatic.

Lighting the backdrop (soft box, second light and reflector)

When using a white backdrop, by placing a light behind your subject so that it's lighting the backdrop you effectively overexpose the background, making it appear pure white rather than grey. This gives that classic 'studio' look.

Why, when, what

What's the best lens for portraits?

For headshots, use a prime lens with a fairly standard or slightly long focal length. You can pay more for wider apertures, like **f1.4**, but often this doesn't offer any real practical advantages when weighed up against the extra cost. For more environmental portraits, where context is important, use a lens with a shorter focal length. Just watch out for lens distortion (see p.25).

Why are my subject's eyes out of focus?

If you're going for a tight headshot with a shallow depth of field, then you and your subject have to remain very still. What's probably happening is that you're focusing on their eyes, but then either you or your subject is moving very slightly before you take the picture. This will shift the point of focus from their eyes to their nose or ears. Using a tripod can help, or try moving slightly further back, or using a narrower aperture of around **f5.6**.

Why is my subject silhouetted?

This will be because they are backlit. A bright light behind your subject will confuse your camera's exposure meter and cause your subject to be underexposed. Move your subject away from the backlight or use Exposure Compensation ☒ (see p.41).

Why is the background still in focus even though I'm using a wide aperture?

This is because you're using a lens with a short focal length (wide angle) and you're too far away from your subject. Try zooming in and also stand closer to your subject (see p.121).

Why do my portraits look so cheesy?

Is your subject constantly smiling? Are you allowing them to play up to the camera? Is their expression or pose a bit contrived? Are you using inbuilt flash? Take more control over your subject. Slow things down, wait for their energy levels to drop and try for something more candid rather than overtly posed. Avoid using your inbuilt flash and make the most of any natural light.

When should I pay strangers to take their photograph?

If you ask nicely, strangers are almost always happy to have their photograph taken without being paid. But if you're photographing someone clearly less fortunate than yourself (the homeless or those struggling in poorer countries) then you may want to give something, even if they don't ask. But it doesn't have to be money. Pens are hard currency in some countries and it's always handy to carry a stash with you when travelling.

What camera is best for photographing people?

Every camera comes with pros and cons, so you need to make sure you use the most appropriate 'format' for the kind of people photos you want to take (pp.74–75). One of the main advantages of medium and large format cameras is increased image quality, meaning you can retain detail while printing really big, like Rineke Dijkstra (p.64), Jeff Wall (p.88) and Thomas Ruff (p.114). But these formats aren't nearly as versatile or convenient as smaller (D)SLRs and rangefinders, preferred by the likes of Bruce Gilden (p.78), Fred Herzog (p.116) and Robert Bergman (p.121).

What's better – film or digital?

Some photographers prefer to shoot film because the grain gives photographs a more 'tactile' look and feel. Shooting film also makes you more considered, as every click has a cost. And, of course, with film you can't check the image as soon as you take it. This focuses your attention on your subject and the act of shooting. And there's a final reason. Digital medium format cameras are very expensive, so for many photographers film is still the only option.

Index

Credits

Acknowledgements

A big thank you goes to this all-star cast of colleagues, friends, family and photographers. Sara Goldsmith, Sophie Drysdale, Peter Kent, Alex Coco, Lewis Laney, Eleanor Blatherwick, Abigail Brander, Nigel Howlett (nigelhowlett.co.uk), Simon Tupper (simontupperphotography. co.uk), Matt Sills (mattsills.co.uk), Bryony and Laurence Richardson, Muzi Quawson, Josh Parry (joshua-parry.com), Nick Parry, Jeannette Lloyd Jones, Luke Butterly (lukebutterly.com), Owen O'Rorke (farrer. co.uk), every one of the fifty photographers featured and an extra special thank you goes to Selwyn Leamy (selwynleamy.com) and Melina Hamilton (melinahamilton.com).

About the author

Henry Carroll is a photographer, writer and speaker. He is the author of the bestselling book *Read This If You Want To Take Great Photographs* and the co-founder of frui.co.uk, one of the UK's leading providers of photography holidays, courses and events. He has an MA in Photography from the Royal College of Art and his photographic work has been featured in a number of international exhibitions and publications (henrycarroll.co.uk).